The Prints of Armand Seguin 1869-1903

Richard S. Field

Cynthia L. Strauss

Samuel J. Wagstaff, Jr.

Davison Art Center
Wesleyan University, Middletown, Connecticut
8 February - 14 March 1980

This exhibition and its catalogue were made possible
by a grant from the National Endowment for the Arts,
Washington, D. C. and a generous contribution from
the Friends of Davison Art Center.

Library of Congress Catalogue Card Number 80-80263
Printed in the United States of America
by Eastern Press

Typography by Finn Typographic
Design by William Van Saun

ISBN: 0-931266-01-7

Acknowledgments

THIS EXHIBITION and catalogue have their beginnings in 1959 when Samuel J. Wagstaff, Jr. was in Paris working on Gauguin. Sam had other irons in the fire, one of which was the publication of a catalogue of Seguin's graphic œuvre. In addition to collecting information and photographs, he also formed a fine collection of Seguin's prints. Many of these are in the present exhibition, and much of the data amassed twenty years ago has found its way into this catalogue. But it would not have happened without the labors of Cynthia Strauss who was my student at Wesleyan from 1973 until 1976. As her senior honors thesis, Cynthia agreed to undertake a study of Armand Seguin. Fortunately, she was able to work abroad for two protracted periods of time, and Sam Wagstaff generously made available all of his prints, notes and photographs. Ms. Strauss' thesis was a major undertaking for an undergraduate, and I realize only today how very thorough and successful it was. We always hoped to turn Cynthia's work into an exhibition and a worthy publication, and now, thanks to the National Endowment for the Arts, Wesleyan University and the art world have an opportunity to study the complete (so far as is known) graphic work of one of Gauguin's least researched followers. It is at this point that the present writer joined the staff, so to speak. I have tried to review every scrap gathered by Ms. Strauss and Mr. Wagstaff and to add what I could. The chronology is very similar to that established in Ms. Strauss' thesis, but the changes and the essay that justifies them are the responsibility of the undersigned. It has been a long time in the making and I hope that this modest catalogue will please both my predecessors and co-workers.

The success of an exhibition, and in this case of the catalogue as well, lies in the hands of the collectors. We have been supported in every way by Pierre Fabius of Paris who has gathered the most interesting and complete collection of Seguin's prints. Eberhard Kornfeld in Bern, Dr. and Mrs. René Guyot in Clohars-Carnoët, Maurice Malingue in Paris, Samuel Josefowitz in Lausanne, and Monsieur and Madame Paul Prouté in Paris have all shared their collections and their knowledge. At the Bibliothèque Nationale, we were assisted by a long list of curators, of whom we would like especially to record the supportive contributions of Jean Adhémar and Michel Mélot. In Nantes we visited the marvelous collections of Dr. Jean Paressant, while in this country we have been enthusiastically encouraged by Arthur G. Altschul whose interests in the School of Pont-Aven go back many years. Abraham Adler has shared his recollections and files with us, and has lent a rare Bernard zincograph to the exhibition. At the Museum of Fine Arts, Boston, we would like to thank Clifford Ackley and Barbara Shapiro; at the Metropolitan Museum of Art, Colta Feller Ives and Suzanne Boorsch. Phillip Dennis Cate, Director of the Rutgers University Art Gallery and indefatigable researcher in fin-de-siècle prints, has unearthed a rare print by Louis Roy for us, and Jim Bergquist, the friendliest of dealers, has been very obliging in making available his fine cache of O'Conor prints. We would also like to thank Jean Chauvelin, Mlle. Paule Cailac, Marcel Lecomte, the family of Galerie R. G. Michel, Henri Petiet, and others in Paris who have answered our questions. Mme. Dominique Denis, Mme. Marie Amélie Anquetil, Mrs. Esther Sparks, Mlle. Anne Roquebert, and Kneeland McNulty have been generous and helpful in their own ways. To all of these persons we would like to convey our very special thanks.

Many undertakings have their less glamorous sides, and these are not always the burden of the organizers, but of those staff and friends who always seem to take their pleasure in being of assistance. I have been vastly aided by several persons at Wesleyan and at Yale and I would like to tell them how much their help was appreciated. They are Alan Shestack, Fernande Ross, Rosemary Hoffmann, Nancy Olson, Marcie Freedman, and Ethel Neumann at Yale; and Jon Higgins, Ellen D'Oench, Robert Kirkpatrick, John Bengtson, Ann Dallas, Janette Boothby, Art Shail, and Melissa Stern at Wesleyan.

4

Finally, I would like to thank the Wesleyan students who participated in various aspects of the thinking that went into this project: Elizabeth Dunn, Katharine Hannaford, Laurie Lalla, Cynthia Roman, and Richard Wright.

This catalogue has been designed with his usual generosity of spirit and respect for materials by William Van Saun, and the text has been very much improved by the tender care and expert editing of Elise K. Kenney. Our indebtedness to the kindness of these two friends can only be suggested by words of appreciation.

RICHARD S. FIELD
Associate Director and
Curator of Prints, Drawings, and Photographs
Yale University Art Gallery

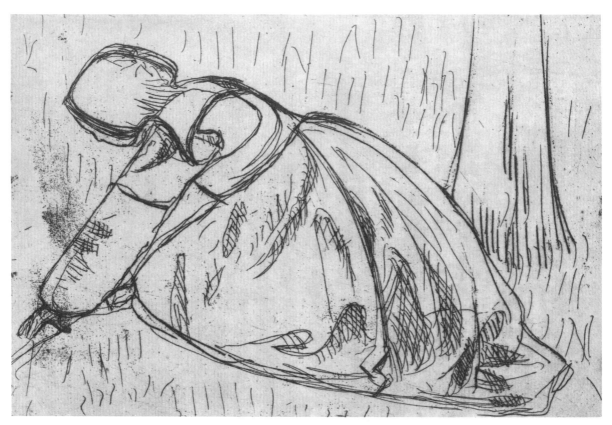

58A

Armand Seguin

I

WHY UNDERTAKE A STUDY of the work of Armand Seguin? Certainly the few paintings that have been identified do not establish him as a particularly inspired artist or, for that matter, as an especially interesting follower of Paul Gauguin whose work forms a constant frame for Seguin's. Furthermore, there is no way that Seguin can be cast in the role of innovator as can Emile Bernard, nor is there justification for regarding Seguin as a kind of chef-d'école as one could Paul Sérusier, and there is no body of critical writing to accord Seguin the position of historical spokesman as did the writings of Maurice Denis.[1] Seguin might have been a rewarding case-study in the relationship between major stylistic currents and their minor decorative adaptations, but his output was limited and too uneven. Yet, his contemporaries and even today's historians accord him some importance and recognize some degree of unfulfilled talent. Rather than trotting out this old chestnut about talent unrealized, a point of view supported by Wladyslawa Jaworska in her recent book, *Gauguin and the Pont-Aven School,* our task will be to examine the patterns of Seguin's career. We will propose that he came to maturity rapidly, manifesting an undeniable inventiveness that atrophied within four years. That Seguin did not pursue the implications of his best works resists explanation; financial need, though a factor, could not have been the major cause of Seguin's failures. Rather, there was a failure of perception, an inability to exploit an inner vision that haunts most creative artists. That some intensity of feeling was operative in 1892–94 cannot be denied, for the works of that period are both the most numerous and the most engaging. Whether Seguin experienced some personal or external catastrophe around 1894, whether he played the masochist to Gauguin's sadist, or whether the sudden cultural conservatism of the mid-nineties sapped the remaining creativity from Seguin, we cannot ascertain.

For these reasons, it is important to examine the work, particularly the prints, since they represent a heretofore unexplored and somewhat unsuspectedly numerous production. The scope of Seguin's printed œuvre has remained in obscurity for the simple reason that there exist so few examples in public collections outside that of the Bibliothèque Nationale in Paris. Thus our first task is to make known what has been inaccessible. A second, quite difficult goal, is to lay bare the few strands of logic that hold together a fairly desultory and capricious œuvre. It is the latter challenge that is the most fascinating, and the only one that will yield insight into the strengths and failures of Seguin the artist. This need was already obvious to Maurice Denis in 1895. His review of Seguin's exhibition is worth citing in full:

To those who have followed since its inception the evolution of those painters successively called Cloisonnistes (Dujardin, *Revue indépendante,* 1886), Synthetistes (1889), Neo-traditionnistes (Pierre Louis, *Art et critique,* 1890), Idéistes (A. Aurier, *Mercure,* 1891), Symbolistes et Déformateurs (A. Germain), the exhibition of Seguin will be of special interest. They will be pleased to recollect something of the forgotten exhibition that took place at the Café Volpini on the Champ-de-Mars in 1889; they will see again those happy formulations of the School of Pont-Aven.

Seguin is one of the few artists who has preserved the procedures of those times. He has made them his, I hasten to add, especially since he has known how to make them serve his own personal expression. With greater freedom than Filiger or Bernard, he persists in using black contours and flat tones—the very essence of Cloisonnisme. But he should be praised for the purity, I would say, classicism of his forms; I love the subtle modelling that he imparts to his figures not so much to simulate plastic relief but in order to enhance the beauty of the contours. He has a sensitivity for *deformation,* he knows how to balance the re-

quirements of sensibility with those of decoration.

P. Gauguin, in his most interesting preface to the catalogue, says of Seguin: his faults have not yet become so clearly defined that he merits the title of master. That is to say that Seguin does not yet bring a balanced or uniform manner to the interpretation of his feelings.

Now one should not hasten to conclusions. For some of his prints, the Parisian subjects executed in a suppler fashion, herald another direction for Seguin's talents.

What is important is that he maintains his stature as a painter; there can be little reason to doubt it, seeing him so strongly committed to the logic of his art.[2]

Sadly, Maurice Denis could not know how the future would deal with Seguin, how few new paintings he would make, how pitifully small would be the total corpus.[3] Nor was he aware that Seguin had already begun to sacrifice those painter's virtues to the more superficial demands of the illustrator. Yet, it is obvious that even the praise Denis offered was doubly cutting. While he tacitly agreed with Gauguin's criticism that Seguin had not yet formed his style, Denis actually used the article for his own ulterior motive, a plea for a return to non-literary Symbolist painting.[4] Even if Seguin's work did avoid the pitfalls of loading the subject (rather than the forms) of a painting with the burden of carrying all its meaning, it is clear from contemporary accounts that Seguin was never regarded as a painter of note. Rather he was seen as an affable man with a pronounced graphic sensibility, an artist who attempted to force his talents rather than nurture his indwelling inclinations. Had he embraced his gifts, he might have become an artist, at least a draftsman, of far greater import. For even in his prints, as this study will reveal, Seguin's way was ever marked by indecision, experimentation, regression, and lack of insight. His was a nature susceptible to and even dependent upon the work of others. Thus the work of real potential, the landscapes and Parisian café scenes of 1893, were never carried forth. So it is

that Gauguin's critical remarks have remained appropriate today: "Seguin is not a master. His shortcomings are not yet sufficiently exposed to merit this title."[5] Both Gauguin and Denis were aware of the inconsistencies in Seguin's work, but both responded to evidence of an original and honest talent. It can come as no surprise that their remarks and the words of Seguin's own letters led Jaworska to craft a fairly romantic picture of Seguin's career as the artist whose tragic life prevented him from attaining the heights of painterly expression for which he was intended, the artist who, in 1898, wrote: "Every day and every night, I dream of pictures which I have no chance of painting; all of my powers are ready and waiting; I weep over my past and the situation it has led up to."[6]

Perhaps the very works which we have just praised (those also singled out by Gauguin), the Breton landscapes and the Parisian scenes, betray part of the problem: a creativity spread-eagled by Brittany and Paris. One senses, as did Denis, the conflict between the nature-based but synthetic art of Pont-Aven which sounded the deep ties between the peasant and his environment, and the more artificial but decorative Parisian styles which were often inspired by a kind of sensational, modish, demi-monde, but occasionally by the exquisitely tuned, deftly underplayed symbolism of private interiors.[7] To some extent, the problem could be expressed as the differences between Gauguin and Munch on the one hand, and Bonnard and Lautrec, on the other. In any case, it is our thesis that these "styles" set up tensions in the impressionable and young Seguin who responded by oscillating among rather than synthesizing their contents. Seguin never became an intimate member of the Nabis,[8] nor was he a staunch supporter of Gauguin and other artists of Pont-Aven. Like his long-time friend, Roderic O'Conor, he remained in touch but aloof (but unlike O'Conor, he did not always have the means for such independence). Too easily distracted, Seguin was most productive when he was most firmly anchored: during 1893 when he worked with O'Conor, and during 1900–1902 when he prepared the drawings for

Gaspard de la Nuit. One could almost claim that Seguin was most successful when he was most eclectic, when he was most free to submit to the influence of the friends and the old masters he most admired (the very essence of the two-hundred-odd wood-engraved images of *Gaspard!*). If Seguin did indeed live out a minor tragedy, it was not that he was forced to become an illustrator, but that he failed to perceive his talent for it.

Given Seguin's temperament, it should come as no surprise that the account of his career as printmaker will be accompanied by considerable uncertainty. But first a word about a key problem in Seguin's chronology, that of the paintings and drawings. With the exception of a blue crayon *Self-Portrait with a Pipe* (1889) in the collection of Arthur Altschul, Seguin's work seems split between Brittany and Paris at the very outset. The etching of ca. 1891, *Woman with the Feathered Hat* (no. 6), derives from Parisian (Nabis) sources, while the drawing of a *Breton Girl* (ex-collection John Langaard, Oslo), signed and dated 1891, is very strongly influenced by Bernard and Gauguin. The nearly caricatural features are Seguin's own idiosyncratic trademark, exacerbating even Gauguin's orientalizing drawing style of the late 1880s.[9] The etching is suave, rhythmic, and decorative; the drawing is brutally direct, intimate, and psychologically unsettling. In Paris, the works tended to be more finished and decorative; in Brittany, more expressive and direct. These two threads intertwine throughout the years 1891–1894, making chronological judgments difficult. When, for example, did Seguin paint the four canvas panels called *The Delights of Life?* The answer embodies a major decision affecting one's description of Seguin's career. If one accepts the usual dating to 1890–91,[10] one posits an artist with gifts of a Bonnard coming very early to a maturity never surpassed during his years of graphic productivity. If, on the other hand, the panels are assigned to 1892–93, as we believe they should be, then one can draw a different picture of Seguin; he may be regarded less as an innovator and painter, but more as a graphic talent who reached a point of maximum

inventiveness at just that moment when the multiple currents of Pont-Aven, the Nabis, and Van Gogh were readily available as sources of inspiration. We have found no evidence to support those who contend that these panels were once part of the decoration of Mme. Gloanec's inn at Pont-Aven (it would appear that Seguin resided next door at the Villa Julia, anyway).[11] In our view these panels are not Breton but Parisian in style and subject, and they reveal the influence of Maurice Denis and Pierre Bonnard. In our discussion of the prints we shall adduce further grounds for the claim that these works belong to 1892–93.

The differences among Seguin's Breton and Parisian works may be amplified. To the 1891 drawing, *Breton Girl,* may be added the oil, *Head of a Breton Girl,* of 1891 or 1892 (whose atmosphere suggests the influence of Eugène Carrière who passed the summer in Pont-Aven in 1891), the *Breton Woman Gathering Nuts,* dated 1892 (once shown by the Silberman Galleries in New York), and the two still lifes included in the Salon des Artistes Indépendants in the spring of 1893 (one of which is surely to be identified with the canvas now in the Altschul Collection). Much more decorative and Parisian are the watercolor study for the *Seated Woman with Feathered Hat* of 1891–92, the panels of *The Delights of Life* of 1892–93, and the painting in the collection of Pierre Fabius, *Breton Girl with a Rooster,* dated 1893. Two smaller canvases, *Les Fleurs du Mal* (Collection Samuel Josefowitz, Lausanne) and *Breton Peasants at Mass* (National Museum of Wales) should be given to 1893.[12] Their exacerbated delicacy of line and visage is not found in subsequent paintings.

The year 1893–94 marks new intrusions, the influences of Van Gogh and O'Conor. A painting is no longer a drawing in large arabesque rhythms, but consists of a denser structure of heavier and smaller units of paint. This change appears in the two undated landscapes, *The Two Cottages* (Josefowitz Collection) and *The Village* (ex-Collection Théodore Duret), and is even discernible in the still-decorative but dulled-curves of the drawing for the

lithograph of 1894–95, *Primavera* (no. 84), and in the well-known *Portrait of Marie Jade.*[13] It is from this time, as well, that we would date the very successful Pont-Aven landscape drawing in the collection of Dr. J. Paressant of Nantes and the similarly handled drawing of *Washerwomen* belonging to the Bibliothèque Nationale.[14] It is unfortunate that so few of Seguin's highly accomplished and attractive drawings have survived.

The dampening of the expressive and decorative modes in Seguin's paintings can, therefore, be dated to 1894. It clearly continues in the so-called *Portrait of Countess Gabriela Zalposka* (Collection Atelier Maurice Denis, Saint-Germain-en-Laye) which should be dated 1896.[15] A wash drawing reproduced by Charles Chassé in 1921 not only may be a study for the painting, but is very close in its obtunded line and deadened psychology to the preparatory drawing for the 1896 lithograph, *Alice* (no. 88).[16]

The continued relaxation of all Symbolist/Synthetist pretensions is thus thoroughly established. The few prints, drawings, and paintings that can be dated after 1895 reveal a process of giving way to the mundane necessities of earning a living. The work is pleasantly anecdotal, and conventionally decorative. Certainly the fan, *Breton Women Seated* (1901), is witness enough to the decline of tension and meaning in the formerly rather elegant and expressive hand of Armand Seguin.

II

SO SCANTY IS OUR KNOWLEDGE of Armand Seguin we cannot even be certain as to how he spelled his name; since we have not seen one of his own signatures with an accent, we have adopted the shorter, more provincial 'e'. Although it is accepted that Seguin was born in Brittany in 1869, we know nothing about his family, not even the town in which they resided.[17] Malingue tells us that Seguin attended the Ecole des Arts Decoratifs (a significant choice, if true) with his long-time friend, Henri-Gabriel Ibels.[18] For all her researches, Mrs. Jaworska adds little more to the factual skeleton of Seguin's career. He is thought to have gone to the Académie Julian in Paris and there to have met those artists who were to form the artist-group privately called Les Nabis.[19] But it was only on one occasion that Seguin is mentioned by any of the Nabis[20] (he appears only once in Maurice Denis *Journals,*[21] although they were reasonably good friends) and never exhibited with them at their exhibitions at Galerie Le Barc de Boutteville between 1891 and 1896.[22] Nonetheless he maintained friendships with Verkade, Bonnard, Vuillard, and Sérusier (at whose house he died on 30 December 1903) throughout his life.[23]

No work from Seguin's hand survives from the 1880s other than the already mentioned *Self-Portrait with a Pipe,* dated 1889. Its stylelessness betrays none of the excitement that Seguin and so many of the other young Parisian artists felt at the exhibition of the Groupe Impressionniste et Synthétiste shown at the Café Volpini in the shadow of the great Exposition Universelle.[24] Looking back in 1903, Seguin wrote, "I was captivated by the paintings of Gauguin, Bernard, Filiger, and Laval, so clear-cut, affirmative and beautiful, I still feel joy at the memory."[25] But it is quite clear that Seguin did not work alongside of Gauguin until 1894.[26] In fact, it appears that there is no reason to suspect that he became attached to the group of Pont-Aven until the spring of 1891, from which time there is a portrait drawing of the English artist, Eric Forbes-Robertson, thoughtfully inscribed by the sitter "Pont-Aven, April 1891."[27] The drawing is not marked by any of the characteristics of the School of Pont-Aven, neither formal decorativeness or ex-

pressiveness. Nonetheless some writers have incorrectly reported that Seguin was one of Gauguin's disciples as early as 1888.[28]

Seguin's first surviving etching, *Nude in the Shadow of a Bat,* dated 1890, is decidedly of Symbolist rather than Synthetist mentality, that is, a Parisian work. Its emphatically academic nude becomes a "modern" work only by dint of the association with the bat, not through any stylistic deformations of natural phenomena. Somehow it reminds one of the final (Bracquemond's?) state of Manet's etching after the *Olympia,* although it might conceivably allude as well to Gauguin's reclining nude, *The Loss of Virginity* (painted in Paris in 1890) or to Bernard's *Madeleine au Bois d'Amour* of 1888.[29] Even the conservative technique—the fine hatching and the use of the roulette—betrays an earlier academic training in etching and not at all the hand of the painter. Only the spray of branches and the shadow of the bat offer decorative and suggestive elements which imply an overlay of meaning (a content that is still unclear). This etching is obviously a first instance of the absorption of new ideas, ideas that would not produce a visually convincing impact until another year had passed.[30]

Seguin's first Breton subjects date from 1891. *La Ronde de Pont-Aven* (no. 2) is inscribed "Pont-Aven 1891." From Verkade's account we know that Seguin was staying in Pont-Aven at the Villa Julia in May, just at the time when Paul Sérusier arrived from Paris.[31] It was Sérusier's rather than Gauguin's art that inspired Seguin's *Ronde.* Seguin's version possesses the same stiffness and naiveté, the same awkward flow of line and rhythm, that relates more to Sérusier's formulation that to either Gauguin's or Bernard's.[32] Jaworska has remarked that there is something peculiarly English about this work; perhaps she is responding to the decorative scattering of dark accents, the artificiality of the children, or the lack of connection between figures and setting. One wonders, in fact, whether Seguin had not spent time in England, as his fluent English suggests.[33] Aside from the very powerful, and very different *Breton Girl* (Langaard Collection), there are no other works on paper that can be associated with

Seguin's first stay in Brittany. His art had come along rapidly since the April portrait of Forbes-Robertson, and very likely through continued absorption of the lessons of Gauguin's art as transmitted by Sérusier and Verkade.

In December of 1891 Seguin wrote to Forbes-Robertson from Paris that he was being consumed by his interest in etching.[34] We believe that he was studying with Henri Delavallée, a painter and etcher of considerable charm and skill who worked in Paris and Brittany in the 1880s and 1890s and who is now totally forgotten.[35] Seguin wrote, "I have never been so wrapped up in etching—from morning to night I'm digging away and when I have a good plate I'll send you and Donaldson some proofs."[36] The etchings from this time (nos. 3–6 and doubtlessly others that have vanished) are heavily worked; impressions from two states survive in several cases. The prints are technically complex and very finished, exploiting dense layers of etching, skillful use of aquatint, roulette, and even *lavis* or open-bite.[37] Stylistically, the new etchings are far more concerned with density of tone and complexity of technique than with the charged drawing that can be observed in the underlying designs. In this there is a hint of Seguin's own conservatism, his technical training holding sway over stylistic innovation. *The Wanderer* (no. 3), for example, while a tour-de-force of aquatint drawing, was basically an established Parisian genre, a favorite of Delavallée. His *Ramasseur de bouts de cigares—Pont de Grenelle* of 1892 may have been executed in tandem with Seguin's etching, so close is it in every particular.[38] Similar *retardataire* characteristics inform Seguin's *Seated Couple* (no. 4) where one detects a strong flavor of Daumier's oils and gouaches.

Late in 1891, the first exhibition of the Nabis (*Symbolistes et Impressionistes*) opened in Paris at Le Barc de Boutteville's gallery, 47 rue Le Pelletier. Seguin did not escape its impact: he manifests a new decorative style in the next etchings, *Man with a Hat* and *Seated Woman with Feathered Hat* (nos. 5 & 6). They are remarkable for the pure contours of the first states that echo the sinuous linearisms of the work of Maurice Denis and Paul Ranson, espe-

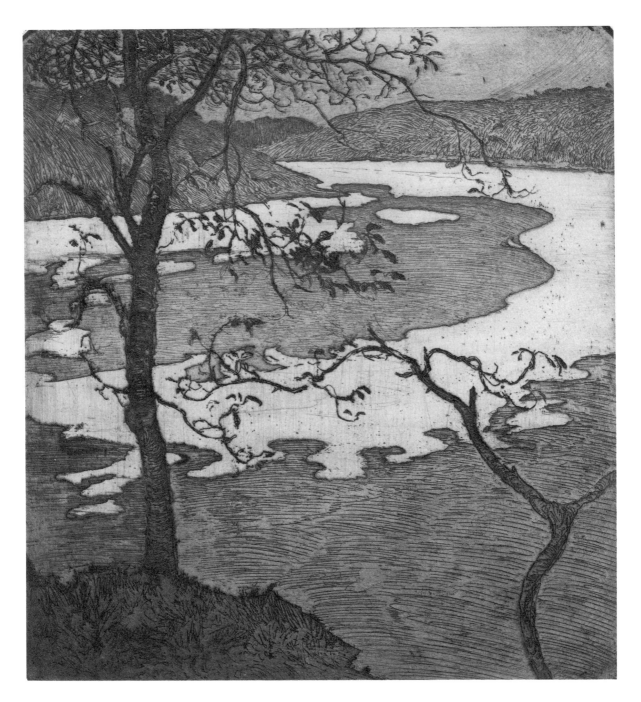

11A

cially the former's drawings for Verlaine's *Sagesse* (1889–90).[39] The more elaborate patterning of Seguin's second states reveals a sensibility conditioned by the works of Bonnard, especially the high–Japan style of a painting like *Woman with a Rabbit* of 1891 (Collection William Rubin, New York).[40] Although Seguin's drawing is marred by inconsistencies of purpose (e.g., the straight, uninflected sleeves of no. 6), these etchings reflect his talent for seizing decorative formulae. By 1892, he had cast aside Sérusier's dour, naive style and was seeking to amalgamate Delavallée's technical facility to a style of elegance, sophistication, and surface decoration. In retrospect, we can acknowledge that no etcher managed to achieve these goals, neither the inventive but dull Charles Maurin nor the highly original Edvard Munch. The medium of choice for the 1890s was to be color lithography, a choice not really possible for Seguin whose love of linear complexity and detail could not be successfully transposed to so free, spontaneous, and broad a medium.[41]

The next group of etchings moves away from the Nabis style, concentrating on landscape and deep space. Peculiarly, not one of these works (catalogue nos. 7–14) is dated or dedicated, and there are, therefore, no objective criteria for their place in our chronology. Although they combine some of the technical complexities developed in the winter of 1891–92, these etchings are only explicable in terms of Seguin's second spring and summer in Brittany. Responsive to his surroundings, Seguin turned away from Parisian high style to more traditional modes of etching. Perhaps Delavallée accompanied Seguin to Brittany and once more his influence was ascendant. In any case, we have not the slightest clue about what inspired the two unique etchings of the flying birds (nos. 7 & 8).[42] The same techniques appear in *The Farm* and *The Sad House* (nos. 9 & 10) whose surreal overtones recall the fantastic etchings of Rodolphe Bresdin, himself an etcher of Brittany and Bordeaux.[43] *The Sad House* shares with the otherwise dissimilar subject, *Trees above the Estuary* (no. 11), an exactly parallel printing technique. In our opinion these three plates, together with *Pine Trees above the River* (no. 12),

were all executed in Brittany on the River Laïta near Saint Maurice, the site of at least one etching of 1893 (no. 25). New is the decided delicacy of forms that yield a space composed of flat, irregular silhouettes. Seguin's use of flat aquatint and open-bite washes is highly unusual for 19th-century printmaking; it is again encountered in works of 1893 (nos. 22 & 23) and of 1894 (no. 69).

The heavy, tonal treatment of masses that had characterized Seguin's work up to this point were giving way to the demands of greater transparency and a more independent role for the thin line of the etching needle. This occurred, we submit, in two of Seguin's most ambitious works, *The Majestic Trees* and *The Hurricane* (nos. 13 & 14) which we here assign to the fall of 1892.[44] One might say that the concentrated and dense linearisms of *The Farm* and the *Swan Flying over the Crashing Waves* are loosened and penetrated by watery, aquatint tones and spaces of *Pine Trees above the River*. The resulting freedom has anticipated the much later etchings of Frank Brangwyn but also is reminiscent of the abstract, airy foliage of the Barbizon etchers, Corot and Daubigny.[45] Perhaps, too, the extensive *retroussage* and wiped tones of *The Hurricane* owe something to Degas's landscape monotypes or even to the *sfumato* of Carrière's charcoal drawings. Seguin's wholesale adaptation of the work of others is bewildering to the historian, of course, but it is another demonstration of his lack of self-determination, a forecast of the waste of worthy talent.

In these two landscape etchings of late 1892, yet another artistic influence makes its first appearance: that of Roderick O'Conor, Seguin's friend from as far back as the summer of 1891, his constant companion in 1893, and his correspondent until the end of Seguin's life, ten years later.[46] The surge of expressionistic verve, the explicit energy of the abstract whorls of line, and the concentration on natural forms must derive from O'Conor's vigorous drawing and strident colorism.[47] It was O'Conor for certain and probably Emile Bernard who transmitted the disciplined natural energies of Van Gogh's style to Seguin. In their thick, stridently colored brushstrokes, O'Conor's canvases owed much to Van

Gogh whose work provided a counterpoint to the stylized linearisms of Gauguin's followers. And Bernard, who was painting in Brittany in 1892, had just been particularly active in organizing a Van Gogh memorial exhibition in April at Le Barc de Boutteville's.

Painting, rather than etching, probably occupied Seguin during his Breton stay of 1892. Perhaps the few canvases already discussed seem to be a scanty production, but there is no reason to believe that a significant number of works have been lost.[48] Seguin simply had difficulty painting. It is to this year, but probably after returning to Paris during late 1892 or early 1893, that we would assign the four panels of *The Delights of Life*. To this writer, they seem far too decorative, too much indebted to the work of Denis and Bonnard of 1892 to be dated 1890–91. For example, the repetitive figure-shapes of the background of one of the panels is almost a steal from Denis's *Danse Breton* of 1891 (Josefowitz Collection) or a borrowing from his drawing for a wood–engraving that appeared in Verlaine's *Sagesse*.[49] Whether Bonnard had come to Brittany during the summer of 1892 is still moot; nonetheless, at this same time he and Edouard Vuillard were most occupied with their Japanese-inspired screens and their most daring theatre program and poster designs.[50] The latter included Bonnard's *France Champagne* of 1890–91 and the often reproduced *Théâtre Libre* program cover of ca. 1892, dedicated to "mon bon comarade Lugne."[51] Every aspect of Seguin's panels can be traced to these Parisian sources—their chic, jaunty shapes, their tendency towards caricature, their sudden jumps in scale and perspective, and, of course, their format.

To the period late 1892 and early 1893 we assign a very mixed group of prints (nos. 15–23) which we believe were executed before the return to Brittany in the summer of 1893. At first, *Woman with Two Children* surprises the viewer by its loose handling. Nevertheless, this treatment may be understood as an outgrowth of the spun line technique of Seguin's late 1892 landscapes, *The Majestic Trees* and *The Hurricane*. Stylistically, there can be little doubt that the dominant model is again the work of Pierre

Bonnard, especially the casual black brush drawings he and Vuillard were perfecting in 1892–93. One thinks of Bonnard's illustrations for *Le Petit Solfège* and of Vuillard's theatre programs.[52] An 1892 painting by Bonnard, *Le Peignoir,* is even closer in feeling to Seguin's surface composition, and to his use of blotchy tone in the etching's second state. The very same sparseness of touch, minus its decorative disposition, can be found in the three etchings (a fourth seems not to have survived[53]) Seguin executed in Valmondois in 1893 (nos. 15–17). These are all signed and dated; their lack of descriptive detail prevents any judgment about the season of the year, but early spring of 1893 should not be ruled out. Their impressionistic technique is again reminiscent of the etchings of Daubigny, Corot, and Camille Pissarro.[54] Of considerable significance is the probability that these new works were executed not on the traditional copper (as were most of the works so-far considered), but on the far less reliable, grainy zinc. Zinc etching simply does not allow the fine, clear lines of copperplate etching; a work such as *The Majestic Trees* would have been impossible to achieve. In the history of printmaking, allowance must be made for the influence of materials and tools, which, in this case, must have been crucial. The same touch informs the first landscape etchings that Seguin would undertake upon his return to Brittany later in 1893 (nos. 24–27).

But landscape was not Seguin's only concern in 1893. The three nude studies (nos. 19–21) are impossible to assess, so much do they depart from the rest of Seguin's work; all three must date from 1893 since *Young Woman in Bed* (no. 19) is dated. The simplicity of structure, the inhibited sense of graphic flow, and the strong denial of patterning run counter to what is observed in *The Delights of Life* panels or even in the two *Café* etchings (nos. 22 & 23) also dated 1893. Yet, the subject of *Young Woman in Bed* (no. 19) not only parallels several of Vuillard's paintings of these years (most notably *Au Lit* of 1891), but in its fusion of model and bedclothes it anticipates Lautrec's wonderful lithographs, *Elles,* published three years later.[55]

It is Lautrec's caricatural wit and demi-monde

subjects that dominate two large etchings, *The Café* and *The Bar* (nos. 22 & 23), which we prefer to date to the beginning of 1893.[56] Despite their new chic, the basis for both etchings was announced in the loosened handling of the preceding prints of 1892–93; even the facial types are merely the distorted relatives of *Man with a Hat* and *Seated Woman with Feathered Hat* of 1891–92. By seeking to synthesize large shapes in the style of high Art Nouveau as it appeared in Lautrec's posters of 1892–95, Seguin had clearly departed from the vertical piling up of small forms characteristic of the screens of 1892–93.[57] *The Café* and *The Bar* must have been the etchings singled out by Camille Mauclair in his review of Seguin's exhibition at Le Barc de Boutteville's: "Pretentiously fantastic in his etchings, of which some recall but exaggerate the distortions of Toulouse-Lautrec, and others are like contorted, architectural landscapes pushed to obscurity, Monsieur Seguin does better by his paintings."[58] What appeared repugnant to Mauclair, however, was an apparent disregard for the beloved arabesque which Seguin now replaced with a brutalized treatment of form and space. So ostentatiously flaunted were his "deformations," that these works anticipate the assault on the materials of printmaking practiced by the German Expressionists during the following decade.[59] One could not blame Seguin for hastily retreating from such an intrepid foray! Yet, it would be a mistake to overlook that aspect of Seguin's temperament that occasionally drove him to excesses. Once more, late in 1894, he would experiment with three boldly drawn etchings that challenged accepted standards of execution (nos. 72–74). After these the spark was to be totally extinguished.[60]

If the variety of Seguin's Parisian productions of 1893 required close study to reveal the qualities they have in common, the etchings produced in Brittany during the summer of 1893 are astonishingly cohesive. Many of the twenty landscapes (nos. 24–43) are dated "Juillet 93" and some are inscribed "Pouldu." Although there are no letters or documents that trace Seguin's movements during 1893–94, it seems clear that in the summer he worked at

Le Pouldu and probably lived in the little quarter on the river side of town called St. Julien. It was there that he must have set up his etching studio to which came Cuno Amiet,[61] Roderick O'Conor, possibly Maxime Maufra,[62] and, in 1894, Paul Gauguin. If one could hypothesize a return to Paris during the winter of 1893–94, suggesting that the two sophisticated lithographs, *The Daydream* and *The Plain* (nos. 66 & 67), were done at that time, then it would be possible to argue that the development of the landscape etchings reached its culmination in these two works on stone.

The first landscapes (nos. 24–28) carry on those of Valmondois (nos. 16–18) which may have been sketched on the way to Brittany. The trees and other topographical features begin to coalesce into shapes and patterns, leaving behind the desultory, Barbizon-like webs of line of the Valmondois plates. The new lines are generally shorter and describe smaller forms than those used in the accomplished plates of 1892. Unlike *The Majestic Trees* and *The Hurricane,* these new Breton plates avoid all experimentation with tone; the lines are wiped relatively clean and no ink is allowed to print from the surface of the plate. Compared to the Paris etchings of 1892–93, there is a return to deep spatial recession notably present in the screen depth of *The Trees beyond the Road* (no. 26). It all suggests a phenomenon that so often occurs in the history of prints: a new subject not only poses its own formal problems, but also leads the artist to simplify his technique and find his way, once again, from simplicity to complexity. Little wonder, for this exploits the very essence of etching, namely its progression from light to darkness as the layers of lines accumulate on the plate.

Gradually, in a plate like *The Village* (no. 29), Seguin disciplined his open lines to conform to both the structure of the picture plane and the diminution of scale with distance. The clouds may signal the intrusion of O'Conor's etching style. As already noted, O'Conor was the transmitter of the new stylistic element that underlay much of Seguin's work of the summer of 1893, the art of Vincent Van Gogh.[63] Through O'Conor's paintings Seguin must have come to understand the potential of Van

Gogh's energetic and highly organized spatial calligraphy. Catalogue numbers 29–34 manifest this developing concentration and should be compared to a painting like Van Gogh's *Walled-In Field at Saint-Rémy* of 1889.[64] As with some of Vincent's drawings, so Seguin's landscapes became a patterned field of pen strokes, albeit lacking those feelings of indwelling forces that Van Gogh impressed on all he saw and painted. Alongside the Van Gogh-inspired landscapes were a number of marine or port subjects that in all likelihood reflected the interest of Maxime Maufra and Henry Moret.[65] Aside from a handful of Maufra's etchings and a single lithograph, there is little evidence that Seguin and O'Conor worked closely with either of these two minor Breton painters.[66]

The almost crystalline structure of Seguin's *Striped Landscape* (no. 34) would seem to mark a logical end to the development of the landscapes; to have proceeded further would have been tantamount to a leap into twentieth-century abstraction. The natural solution was to avoid such advanced solutions (even Denis did not advocate pure reductionism[67]), and to continue in a more expressionistic vein. This Seguin did in eight of his most successful and significant landscapes (nos. 35–42). *Landscape with Figure and Large Tree* introduced a new organic rhythm to the space of the entire landscape. *Landscape, Le Pouldu* and *Landscape with Bushes, Le Pouldu* intensified this newly found organic structure by increasing the number and density of landscape elements over the entire picture surface. Seguin succeeds in combining O'Conor's swirling rhythms and Van Gogh's spatial structures with his own love of shape and flowing line. Although painters like Gauguin were critical of Seguin's tendency to submerge himself in the technique of printmaking, these particular landscapes deserve to be ranked with some of the best of the century, even those of Pissarro.

But again the historian must ask why Seguin failed to persevere, to maintain a critical dialogue with his own art more than with the external world. It would seem that no sooner did Seguin hit upon some new synthesis than he wished to amalgamate some other, extraneous element to it. Occasionally his impatience succeeds, as in *Farmhouse Surrounded by Trees* (no. 38), a work strongly impressed by O'Conor's swirling masses but far more charged with graphic and symbolic content—a work of the Pont-Aven School at its best. But Seguin had so little desire to articulate literary content that he was easily seduced by the tonal implications of richly worked lines rather than by the suggestivity of draftsmanship. If one looks to the works of the next years, it is the charged and expressive line that is gradually abandoned, not the fascination with tone and pattern. For this reason, we feel able to place the very handsome but emphatically tonal treescapes (nos. 39–41) after the more linear abstractions of 1893.

Although Seguin wrote in 1903 that the Breton countryside "marvelously facilitated the pursuit of the synthetic style,"[68] this expressive wedding of natural and artificial forms was difficult for Seguin to maintain. *The Apple Trees at Le Pouldu, The Pine Trees,* and *The Billowing Trees* are among Seguin's most attractive works, but they do foretell the adoption of more conservative solutions. Certainly this tendency was in the air in 1893–94, as a growing anarchism threatened both the political and artistic centers. Denis took pains to point out in his commentary on the Seguin exhibition of 1895 that Symbolism had lost its primary, formal focus. Bernard and Denis turned to devotional imagery and traditionalism, while Anquétin sold out completely to Baroque composition; Maillol abandoned his flat, Art Nouveau style for the fullness of classical sculpture; Bonnard slowly lost his fascination with Japonism; Gauguin worked in an increasingly descriptive and frankly allegorical mode; and even Lautrec turned away from the outlandish wit of his 1893–94 posters. For Seguin there would be one more experiment with boldly stylized, but clearly decorative etching, begun in the two landscapes we have placed at the end of the 1893 series, *House on Hilltop overlooking the Sea* and *Willow Trees by the River* (nos. 42 & 43), and culminating in the three works of 1894 already mentioned (nos. 72–74). But the sustained effort embodied in the 1893 landscapes would not appear again in Seguin's œuvre until the

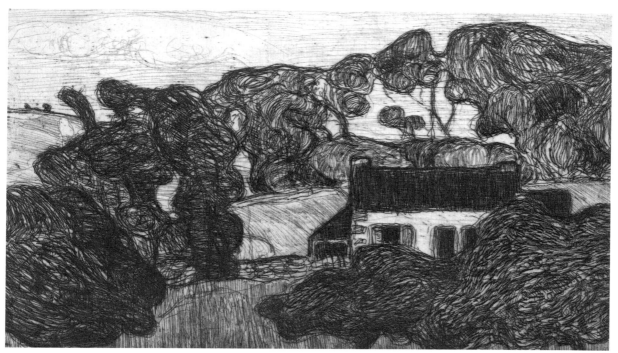

38A

very different and far more derivative illustrations of 1900–03 for *Gaspard de la Nuit.*

It is hard to accept that the sketchy, almost undisciplined series of Breton figure studies (nos. 44–65) must be assigned to 1893, the same year as the landscape series. They are surprisingly sparse; they are drawn with awkward, angular lines and rhythms; and, with few exceptions, they seem to reflect an entirely different stylistic direction, one very much influenced by Emile Bernard. We know that Seguin and Bernard worked together in both 1892 and 1893,[69] but we cannot readily date these figure studies earlier than 1893. Our evidence consists of the following observations: first, the closely related *Young Woman in Bed* (no. 19) is dated 1893; second, one of the Breton studies is incorporated in a work published in 1894 [*Breton Woman Kneeling before a Tree* (no. 58), is incorporated in the highly finished *Evening* of 1894 (no. 68)]; third, several of the figure studies were executed on plates that bear traces of previous landscape images; fourth, the latest echo of this figure style appears in the copy of Filiger's *Saint Jean* (no. 81) which can date no later than February 1895;[70] and, finally, the 1893 pastel recently purchased by the Musée de Brest is a Breton head drawn very much in the spirit of the etchings."[71]

In general the series may be regarded as preparatory for a work which has not survived, a painting or a large etching, *Les Ruisseuses* (*The Flax Retters*). Some idea of the monumental ambitions harbored by Seguin is offered in three large plates which do exist (see nos. 47, 62 & 64). *The Flax Gatherers* and *Three Breton Women Resting after Work* return to the powerful conceptions of Bernard's best Breton paintings like the *Buckwheat Harvest* of 1888 (Collection Josefowitz) or even his tapestry, *Breton Women Picking Apples* of 1892.[72] More directly linked with Seguin's studies were Bernard's zincographs of 1889, *Les Bretonneries*.[73] Both Seguin's and Bernard's drawing styles imply the corporeal existence of the weighty Breton peasant without being able to translate it into convincing physical action; the forms tend inevitably towards two-dimensionality. Gauguin's zincographs of

1889, on the other hand, combine more active two-dimensional contours and a variety of surface textures with a far more convincing sense of weight and inner movement, as in *Les laveuses* (Guérin 6). Gauguin's peasants are not simply signs of a concept nor are they ideographs about the relationship of the peasant to his environment as are those of Bernard and Sérusier. By means both abstract and illusionistic, Gauguin compelled the viewer to feel the dependence of the peasant on the soil, and empathize with a state of mind kept primitive by the burdens of material existence. The simple acts and gestures that Gauguin distilled from his observations awaken feelings of a timeless and hopelessly repetitive existence.

By 1892 Bernard had abandoned all pretense of emulating these inner resonances of Gauguin's art; he was content to produce what must still be regarded as very handsome decorative Breton scenes like his *Bretonnes aux ombrelles* (Musée d'Orsay, Paris). For Seguin, too, it was Bernard rather than Gauguin whose example was most comfortable. A combination of borrowed styles informs Seguin's figurative etchings of 1893. Nowhere does he give in to the cursive arabesques of Parisian taste, but clings to a somewhat awkward, almost angular mode of drawing. This is most clear in works like *Breton Woman with Cap, Breton Woman Reclining by a Tree, Decorative Figure: Breton Woman Holding a Bundle of Flax* and *Two Breton Women at Work* (nos. 50, 52, 55, & 59). Seguin is decidedly not at ease when he depicts physical activity. His images are hieratic—that is, the simple traces of the etching needle, the means of depiction, are clearly disciplined by the flatness of the metal plate. By exploiting an almost monotonous honesty of execution, Seguin sought his own kind of equivalence between the ritualized acts of his Breton women and of his own hand.

We hope we have made a virtue not of ineptitude but of deliberate choice. Certainly it is most instructive to compare these Breton figure studies with the far more sophisticated lithographs we believe were done in Paris late in 1893 after Seguin's return from Brittany (nos. 66 & 67), that is, subsequent to both

the landscape and figure etchings. *The Daydream* does manage to capture something of the movement of Gauguin's lithographs although it may owe a more direct debt to Bernard's zincograph of *The Harvesters* of 1889,[74] with its large undulating and regularly hatched areas of drawing. *The Plain* (no. 67) with its similar rhythmic sensibilities (one must recall that the lithographic crayon was a far more fluid drawing instrument than the etching needle) is a most original landscape.[75] Hans Hofstätter has gone so far as to propose that this work anticipated the melancholic landscapes of Edvard Munch![76] Not only had Munch already been working in this mode, but there exists an explicit prototype for Seguin's work in Maurice Denis' lithographs for André Gide's *Le Voyage d'Urien* published in the spring of 1893.[77] Nonetheless, *The Plain* is a much more ambitious work and is another example of Seguin's potential. In it, Seguin succeeds in wedding form and subject to evoke a sense of man's own entrapment in the repetitive and suffocating round of activity necessary for basic survival. The shapes of the terrain not only contain man's labor but seem to create rhythms to which he as well as the viewer is compelled to accommodate. Seguin's unusual accomplishment results from his ability to equate the flow of natural events in man's life with the character of the forms comprising man's space. The arabesque rhythms inhabit the odd rocks, mounds, animals, hills, and the shoreline throughout the image, only to be resolved by the flat but limitless sea of the upper fifth of the picture.

If even so harmless a landscape as *The Plain* harbors overtones of despair, it should be remarked before leaving the Breton figure studies that they too partake of a very suggestive genre, significant to many of the artists working in both Pont-Aven and Paris towards the end of the century. The harvest of fruit or grain is a subject without a long history in art. The plucking of fruit dissociated from its explicit link with the Edenic myth makes few appearances in art before the mid-19th century and Puvis de Chavannes. Although the gathering of fruit or even the harvesting of flax, grain, etc., may appear as a totally innocent, peasant activity, it can never

be totally removed from its associations with ideas of Arcadian innocence.—and the loss thereof. "Et in Arcadia Ego!"[78] Death and sin are to be found even in paradise; the Breton peasant far removed from the complications of a decadent urban existence is not unaware of death and the sins of life. It was in reaction to this pessimism that the Nabis and Pont-Aven artists created their images of women and children plucking fruit, and that Gauguin included his androgynous fruit-picker in the masterpiece of his second voyage to Tahiti, *D'où venons-nous?*. They are clear expressions of the longing to return to a state of innocence. They represent rituals without evil consequences enacted in an Arcadian grove.[79] Ultimately, however, the fruit gatherer theme is only the benign form of what in the hands of other Symbolists was an explicit yoking of sexuality and death. The relationships between work and death, between daily sustenance and original sin, especially in the images of Gauguin, have been imaginatively analysed by Wayne Andersen.[80] But is it possible to associate Seguin's *Les Ruisseuses* with these same preoccupations? Perhaps it is not entirely gratuitous in so far as they do partake of the iconography specific to their time. At least two of the etchings, furthermore, could be regarded as explicit fertility symbols (nos. 53 and 62) since they depict women gathering or even embracing suggestively phallic sheaves of flax.

There is no data at all on Seguin's work or movements in the winter of 1893–94. We only guess that he returned to Paris, to his studio at 54 rue Lepic, and undertook his first experiments in lithography on stone. *The Plain* and *The Daydream* are the only surviving results. Their style and technique suggests that they were done in the company of Sérusier, Maufra, and O'Conor, each of whom executed one or two very similar landscapes in 1893–94.[81] What we do know is that Seguin was working with Gauguin in Brittany early in the spring of 1894.[82] Seguin's most finished etching, *Evening* (no. 68) is identical in motif, point of view, and time of year with Gauguin's undated canvas, *Farm in Brittany*.[83] The etching was published in Paris in the July–September number of *l'Estampe originale*, and

is not only his best-known work but also one of his most successful. It is a detailed, unified work, decorative and graphically attractive. It does not embody Gauguin's mastery of space and articulation of detail, and, like much of Seguin's work, is somewhat two-dimensional. Note how the stone wall melts into the finely hatched verticals of the field, how the planes of the ground fail to create enough space for the carefully rendered but still relatively flat Breton woman, how the trees are more like stage flats than part of a three-dimensional space. But the overall effect is of a gentle, filtered evening light, a time when depth-perception is diminished, and lacy forms of the emerging foliage evoke a mysterious mood far removed from the breezy, spring day of Gauguin's painting.

Similar in technique to *Evening* is *Sailboat on a Mountain Lake* (no. 69), a work at one time given to Paul Signac (1863–1935). It is very close indeed to the Neo-Impressionist's decorative drawing style, and most closely approximates Signac's *Le Clocher de St. Tropez*, a lithographic variant of which was published in the same number of *l'Estampe originale* (VII) as Seguin's *Evening!* [84] Seguin shares with Signac, perhaps only in this work, an interest in a vibrant but highly decorative line whose organization into units of regular graphic textures implies something of the Neo-Impressionist's broken surface color.

Seguin made relatively few prints during the summer and fall of 1894; aside from the accounts of the fight at Concarneau in which Seguin, O'Conor, and Gauguin were assaulted by a group of sailors (Gauguin ended up with a broken ankle), there are no documents at all. We assume that Seguin and Gauguin worked together quite often; the latter even hoped that Seguin would accompany him on his return to the South Seas. As would be expected, Seguin's work reveals the influence of the older artist. Certainly the woodcut, *Three Breton Women with Infants* (no. 70) was executed under Gauguin's direction. Gauguin's own graphic activity during his months of convalescence in Pont-Aven included a number of woodcuts and various experiments in monotype. [85] Two more Seguin prints reflected Gauguin's monotypes, the open-bite aquatint, *l'Apparition,* and what is probably Seguin's only surviving example of a monotype, *Study of a Nude* (nos. 77 & 78). The broad handling of these works stands in unexpected contrast to the tight discipline of the etchings of the spring of 1894. The new looseness also informs *The Idiot* (no. 79), an image that may be a caricature of Gauguin, but certainly refers to Gauguin's own *Portrait of Stéphane Mallarmé* (Guérin 14) of 1890.

The major experiments of late 1894 were the three decorative etchings, *A Summer's Day, Breton Women by the Sea,* and *Trees at Night* (nos. 71–73). Although they appear as yet another departure from anything previously seen in Seguin's œuvre, their open, curvilinear rhythms form part of the same bold and painterly style derived from Gauguin. The heavy lines, in fact, are quite similar to those that began to show up in the last landscape etchings, *Willow Trees by the River* and *Evening* (nos. 43 & 68), and are paralleled by the decorative handling of the white lines in the woodcut of late 1894, *Three Breton Women with Infants* (no. 70). Such a technique also appeared in Delavallée's work, a distant relationship to be sure, since he had long departed for the Middle East. [86] Most likely there was a direct appropriation of the woodcut technique to which Seguin was constantly exposed by Gauguin. A peculiarly restrained freedom permeates this combination of brushed and cross-hatched lines, a hybrid of the pen, the burin, and the gouge. Whether Seguin employed the lift-ground technique of aquatint is a bit academic, [87] but the woodcut influence and the horizontal format are highly reminiscent of Gauguin's just-completed *Noa-Noa Suite*. [88] Yet Seguin goes beyond his teacher. Not only are two of these etchings highly brutal in their exploitation of technique, but their grossly caricatural renderings of the human figure verge on the language of the Fauves or the German Expressionists. In fact, the three reclining figures obscured behind the painterly ground of *Breton Women by the Sea* (no. 73) are dead ringers for the abstracted graphic forms Kandinsky would evolve in 1910. [89]

Seguin must have returned to Paris with Gauguin

in November of 1894.[90] Perruchot reports that they were often together in Paris during the early months of 1895 (Gauguin set sail for Tahiti again in June);[91] he even claims, without supplying documentation, that the two made a very hasty trip to Brittany in March of 1895. In February of 1895, at Le Barc de Boutteville's, Seguin received the only one-man exhibition ever accorded him. The catalogue, with a preface by Gauguin, listed seven paintings, thirteen drawings, and seventy-six prints. On the 18th of February, Gauguin placed many of his own works up for auction; two were purchased by Seguin![92]

It was also during the winter of 1894–95 that Seguin began contributing to l'Ymagier, a monthly devoted to the arts, particularly to the art of the woodcut. In January Seguin's woodcut (no. 70) appeared, without the November 1894 verses by the critic Charles Morice, "A Paul Gauguin!." In the same issue, Seguin's zincograph, *Breton Woman Reclining by the Sea* (no. 84) was announced; and in April 1895, l'Ymagier published Seguin's fine but rather trivial aquatint study of a *Nude with Hands behind her Head* (no. 76). Is there not a trace of the mulatto in the model, yet another tie with Gauguin?"[93]

We now come to the most controversial point of the Gauguin-Seguin relationship, the etching *Woman with the Figs* (no. 80). This etching has been given in part or in its entirety to both Seguin and to Gauguin, and dated 1895 by most writers.[94] Are we to believe that it was executed in Brittany (St. Julien is a little quarter of Le Pouldu) at a time when Gauguin's presence there cannot be established? If, as we feel, this work is and was from the beginning a cooperative venture, its inception must date from 1894 when the two artists were obviously settled and working together. Furthermore, the share that is certainty attributable to Gauguin is the design which clearly relates to works executed in the fall of 1894, namely the *Still Life with Flowers and Fruit* in the Museum of Fine Arts, Boston (Wildenstein 406),[95] the monotype, *The Angelus*, dedicated to O'Conor (Field 25),[96] and the woodcut, *Manau Tupapau* (second version; Guérin 36).[97] All of these compositions are organized by a series of rounded arcs that are specific to Gauguin's work of 1894. Even the blank strip to the left of the seated woman relates to decorative motifs in the woodcuts like *Manao Tupapau* (first version, Guérin 18) and *Te Faruru* (Guérin 21).[98]

On the other hand, it is not difficult to find both stylistic and technical similarities in Seguin's work. The woman's face, atypical for Gauguin, resembles the new, narrower features found in three Seguin prints of 1894–95 (nos. 80, 82, & 84). The drapery is most assuredly drawn by the hand responsible for the isolated bit of cloth in the *Primavera* drawing of late 1894 or even that found in the painting of 1892, *Breton Woman Gathering Nuts*. The decorative handling of the face and dress of *Woman with the Figs* is not at all dissimilar to that lavished on the Breton peasant in the etching of earlier 1894, *Evening* (no. 68), while the landscape recalls the swirling forms of several Seguin studies, particularly *Farmhouse Surrounded by Trees* (no. 38). Nevertheless, there is a delicacy and a sensitivity to shape just a trace too refined for Seguin. The printer Delâtre claimed that Gauguin drew the entire image in the presence of O'Conor and added that Seguin's role was limited to the grounding and etching of the plate.[99] Why then are there no impressions signed by Gauguin? Boiling down all aspects of this tempest in a teapot, it seems clear that both Seguin and Gauguin participated in the making of the etching, although we feel that Seguin had the major role. What is agreed upon by all is that the corroded plate was somehow unearthed and reworked by Seguin prior to its being used for the one-hundred impressions that appeared in *Germinal* in 1899.

The main thrust of Seguin's printmaking activity in late 1894 and early 1895 was lithography, specifically that somewhat cruder version on metal, zincography. The six zincographs offered by l'Ymagier in July 1895 probably included our catalogue numbers 83–87 (we have never seen a set of these prints together).[100] Drawing on zinc enjoyed a modest interest in the early 1890s; Gauguin and Bernard had used the medium in 1889, Bernard again in 1892. Louis Roy (1862–1907), a little-known friend of Gauguin, executed a few rather dull zinco-

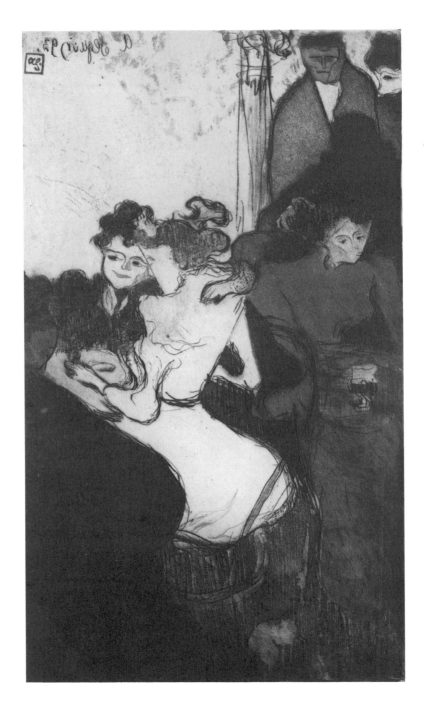

graphs for *l'Ymagier*. He may have been responsible for two of Gauguin's lithographs on zinc, *Two Seated Tahitians* (Guérin 87) for *l'Ymagier* and the almost unknown *Parao Hano Hano*.[101] The short-lived periodical, *l'Epreuve* (1894–95), was filled with zincographs, including one by Gauguin (Guérin 51) and an advertisement for *Imprimerie Lithographie Monrocq Frères—Fondateurs de la Lithographie sur Zinc*. Almost all of these zincographs are fairly minor works. Seguin was more ambitious but one senses that he must have experienced a deep disappointment in these anecdotal images, each crammed with more detail than the next. *Breton Man,* dated 1894, is the freest and most experimental, being drawn solely in wash. The figure still partakes of the slightly caricatural mode of the early nineties, while the trees are nearly identical with those of the lift-ground etching, *Trees at Night* (no. 74). *Breton Woman Reclining by the Sea* (or *Primavera,* no. 84) is the only zincograph one encounters frequently, suggesting the others were never really published. The pose of the model is similar to many of Gauguin's earlier Breton women,[102] and is a reprise of Seguin's own *Nude in the Shadow of a Bat* (no. 1). But what a world of difference is there between Gauguin's brooding, heavy, expressive bodies and the flat, mostly decorative forms of Seguin's zincographs. Although an attractive lithograph in its combinations of flowery, wash textures and crayon lines, *Primavera's* content is limited to a vague sense of nostalgia. The port scene (no. 85), with its fishermen, nude bathers, and distant city (a reference to Dürer's *Saint Anthony* engraving of 1518) is more like a fairy tale illustration than a Breton scene.

The increasing concern with petty details and complex tonalities marks Seguin's final abandonment of the principles of the School of Pont-Aven. Perhaps this underlay Seguin's comment to Pissarro who wrote to his son Lucien:

> Curiously enough his [Gauguin's] own pupils are beginning to drop him and returning to good and simple nature. One of them, Seguin, who has just had a show at Le Barc de Boutteville, admitted to me that he had been barking up the wrong tree and that I was completely right.[103]

Thus another Seguin zincograph, *The Bathers* (no. 86) is an empty echo of Gauguin's *Baigneuses bretonnes* (Guérin 3). Although the village of Pont-Aven still appears in the background, it is but a stage prop and not an integral part of the mood of the composition. The same view of Pont-Aven appears in the zincograph called *The Toads* (no. 87), the meaning of which we have not been able to discover. How much has Seguin given way to illustration! The entire picture plane is filled with details of faces, figures, animals, foliage, and landscape, a clutter that denies style. Ironically, just this aspect of Seguin appealed to the dealer-publisher, Ambroise Vollard, when in 1900 he was looking for an artist whose illustrations would appeal to French bibliophiles: "I thought of Armand Seguin, whom I knew was capable of 'pushing' drawing to its very limit."[104] The same loss of psychological content stamps the rest of Seguin's work until his death in 1903. Each form is given over to a merely decorative existence as can be seen in three works of 1896: the woodcut *Breton Woman from Pont-Aven* (no. 90), the drypoint frontispiece for Rémy de Gourmont's *Pilgrim of Silence* (no. 91), and the bilaterally symmetrical lithographic fan, *Breton Couple by the Sea* (no. 89).[105]

What happuened to Seguin after Gauguin's departure for Tahiti in June of 1895? Some of the details will emerge only after scholars have access to the 110 unpublished letters, from Seguin to O'Conor.[106] Generally, Seguin appears to have been set adrift, both materially and artistically. According to Denys Sutton, Seguin returned to Pont-Aven in July of 1895; his closest friend must have been the reclusive Charles Filiger (1863–1928).[107] But before leaving Paris, Seguin completed his best-known painting, the *Portrait of Marie Jade* (not included in the February exhibition at Le Barc de Boutteville's). The sitter, who was the daughter of Charles Morice, has written that the landscape background had been reworked by Gauguin.[108] Painting was still Seguin's major love and still his major stumbling block. It was probably not until June 1896 that he managed to finish his next oil, the *Nude in a Landscape*.[109]

Sometime during the next year he arranged to have an exhibition of painted fans, works executed strictly for survival.[110] We learn of Seguin's distressful circumstances in a letter addressed to Denis in September 1897.[111] Living with Georges Morand, he is penniless, and yet defends himself against some scurrilous charge that he had failed to fulfill the terms of a commission (presumably the illustrations for *l'Image* that appeared in the September and October 1897 numbers, catalogue 92). In November of 1897 one drawing by Seguin was reproduced for the cover of *Cri de Paris*.

Mrs. Jaworska has suggested that in 1898 Seguin might have been commissioned to execute some murals, but details are not furnished.[112] A letter to O'Conor of 18 September 1898 mentions a painting of women on the beach (this work does not seem to be known), while another letter of 1 December bemoans the fact that Seguin has not been able to paint from nature or from a model for the better part of a year, adding: "I can't be an illustrator—I was born for better things than that, and I'm merely repeating myself when I tell you that this is the only thing that really makes me suffer."[113] Perhaps he was alluding to his unsuccessful attempt to join the staff of illustrators working for the low-humor review, *Le Rire*. It was at this time, too, that Seguin must have tried to apprentice himself to the lithographer, Emile Feuerstein in Saint Gervais.[114] The four years from 1896 until 1900 must have been grim and unproductive, to say the least.

Finally, in 1900 the commission from Vollard came through. The publisher of Bonnard's sublime illustrations for Verlaine's *Parallelement* ordered 213 designs for wood-engravings to adorn Aloysius Bertrand's *Gaspard de la Nuit*.[115] Inspired to work, Seguin left Paris where he had lived with the painter Henry de Groux, and settled in the Breton town of Châteaulin. Nearby was the Pont-Aven painter, Henri de Chamaillard, and in the next town, Châteauneuf-de-Faou, lived his old friend, Paul Sérusier. Gradually Seguin's health began to fail, but he managed to finish the Bertrand drawings and actually began another project for Vollard, illustrations for Lord Byron's *Manfred*.[116]

Seguin's last months must have been filled with moments of nostalgia which found their expression in the three articles he wrote for *l'Occident*. They formed a willful and disjunctive narrative that played fast and loose with history, but it formed the first account of the Pont-Aven painters by one who had known and worked with them all. Seguin spent the last six months of his life with Sérusier at Châteauneuf-de-Faou where he must have once more taken up the brush.[117] At least two works have survived from the period, one of which is dated 1903, *Harvest in Brittany* (former Collection Mlle. Henriette Boutaric, Paris), and another undated, *Seaport* (Private Collection, U.S.A.).[118] But, of course, the major concern of the last years were the drawings for *Gaspard de la Nuit*.

In an unpublished letter from Seguin to Denis, written late on the tenth of July 1902, Seguin confides: "I was inspired by all the masters which will give the book . . . a curious effect. The text is a pretext for it in truth. But that is not my trade, and in my sad situation it is absolutely impossible for me to paint. . . ."[119] Like Seguin, Aloysius Bertrand never lived to see his own Gaspard in print; he died in 1841, one year before its publication. His text recounts and describes the nature of a mysterious book, a gift made to the author one murky night in a medieval quarter of Paris. It was an unknown *clochard*, Gaspard de la Nuit, who turns out to be an agent of the Devil, that lends Bertrand this book of magical spells and images. It will reveal the hidden essence of art and poetry, much as if it were a book of forbidden rites of some secret religious cult. In reality, Bertrand's text is filled with epigraphs taken from other writers and allusions to the great painters. It was as if Seguin had fallen upon a text that conformed perfectly both with his eclecticism (his dependence for inspiration on the art of others), and with his almost religious fervor for the art of painting, an object of desire which, in Seguin's experience, had always taken the form of forbidden fruit.[120]

Seguin's illustrations are a perfect match to Bertrand's "medievalism" in their multiple borrowings from the Old Masters. These include Dürer, Callot,

Rembrandt, Goya, Fuseli and Blake, as well as allusions to numerous other artists like Teniers, Bega, van Ostade, on the one hand, and to Belgian and English 19th-century illustration styles of Behrens, Toorop, Beardsley, and Ricketts.[121] Furthermore, the wood-engravings are easily divisible into two basic groups: those done in outline and those in tone. The first style is really an adaptation of several modes of sixteenth-century woodcutting, styles which still looked "primitive" and medieval to the 19th-century eye.[122] The second group exploited the complex tonal accomplishments of 19th-century wood-engravers (the Beltrands were among the most skilled).[123] A small number of these tonal illustrations are carried to a degree of painterliness so that the image appears to be a wash drawing or lithograph.[124] It is not clear whether these distinctions are those of the Beltrand family members, or those made by Seguin, since the drawings have not survived. One must assume that these decisions were made by the artist; perhaps they even corresponded to some literary ideas not yet correlated. It is true that this book is and was old-fashioned in its style and intent, created as it was for the conservative French bibliophile. But that does not detract from the success of its design or from the very satisfying manner in which illustrations evoke and parallel rather than describe the texts.

Art history demands more than a description of the works that may be attributed to a given individual. We want to understand art and its role in society, and one way we project ourselves into this process of evaluation is by understanding change and then hypothesizing reasons for such change. We know that our description of the variables within the work of Armand Seguin cannot be entirely accurate. It has been our goal to propose as logical a picture as possible in the hope that Seguin could be better comprehended as an artist of his time. On the other hand, Art history does not demand praise or condemnation; we have not sought to establish an identity that falsely inflates Seguin's position in his own world. He was, simply put, an artist of his day whose role both as a human being and as an inventor of images was important for those who knew him. He did not shape the course of modern art, but he did and does add to our understanding of the ebb and flow of a period of complex possibilities. In so far as some of his works give pleasure in their own right, he has made a tangible and permanent addition to our culture and our lives.

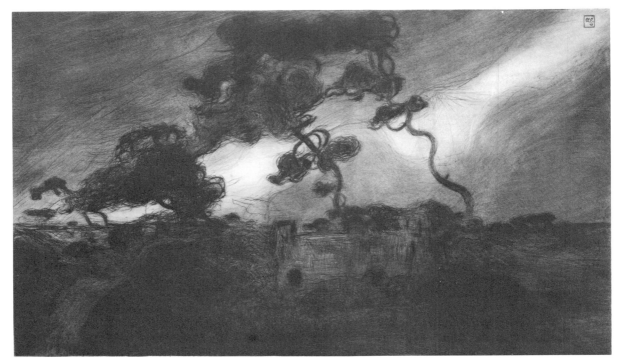

14A

Notes to the Catalogue

WITH FEW EXCEPTIONS Seguin's prints exist in such limited numbers that we have undertaken to describe every impression known to us. The exceptions include those works published in *l'Estampe originale* (no. 68), *l'Ymagier* (nos. 70, 76, & 85), *Germinal* (no. 80), those published in books (nos. 91, 92, & 93), and the recent impressions of the twenty-four plates included in the Malingue Restrike edition(s) of ca. 1960 (nos. 19, 20, 21, 24, 25, 28, 34, 35, 44, 45, 48, 49, 50, 51, 52, 54, 55, 56, 57, 60, 61, 63, 75, & 82). We know of complete collections of these reprints in the Bibliothèque Nationale, Paris, and in the collections of Stéphane Malingue, Paul Prouté, Samuel Josefowitz, and Samuel J. Wagstaff, Jr. Of these 24 plates, impressions pulled by the artist are known of at least 14 subjects. The restrikes were printed on a fairly unsympathetic ivory, wove Arches paper in an edition of 30. A smaller edition on a thinner Japan (Prouté collection, for example) was also pulled; some of these are supposedly stamped and numbered, although no such examples have come to our attention. All of Seguin's own impressions from these rather sketchy zinc plates were made on identifiable 19th century papers (the Arches he used was laid, not wove). The plates themselves were found by Pierre Ibels, son of Seguin's friend and fellow-artist-illustrator, Henri-G. Ibels (1867–1936). After Malingue's editions, they passed into the collection of Samuel Josefowitz of Lausanne.

It has been impossible to establish a satisfying chronology. We still feel uncertain about the placement of several works, including catalogue numbers 19–23. 1892–1894 were years of intense activity for Seguin, but we lack the kind of documentation of his movements that would have helped to refine the ordering of our catalogue. In any case, the present chronology was compiled by Strauss and Field, but whatever faults may be discovered are solely the responsibility of the latter. The reader is referred to the introductory essay for the rationale of the present chronology. The general nature of the groups we have established is as follows:

1–6	Earliest works, 1890–91, mostly figurative
7–14	Experiments, 1892, dense treatment of landscape motifs
15–23	Parisian subjects, 1892–93, a new looseness
24–43	Breton landscapes, 1893, towards a graphic structure
44–65	Breton figure studies, 1893–94, project for Les Ruisseuses (The Flax Retters), sketches on old fragments of zinc
66–70	Paris, 1893–94, works probably commissioned and worked to a considerable degree of finish
71–82	Assorted experiments, 1894–95, Paris and Brittany
83–89	Lithographs, 1894–96, including six zincographs announced as an album for *l'Ymagier*
90–93	Last works, 1896–1903, including designs for 19 wood-engravings that appeared as page frames in *l'Image* and 213 wood-engravings that illustrated Vollard's edition of Bertrand's *Gaspard de la Nuit*
A–B	Two doubtful pieces

Obviously some of Seguin's printed œuvre has been lost. We have attempted to correlate those we have found with the list of prints exhibited at Galerie Le Barc de Boutteville in February 1895, and this we have done on a very speculative basis. Nevertheless, we have neither been able to account for all of the prints nor find counterparts for all of the titles. Furthermore, the exhibition at Pont-Aven in 1961 contained one if not two works we have not been able to trace (no. 155 *Portrait of the Ceramist Georges Rasetti*, 1892, 180 x 320—could this have been our no. 5?; no. 158 *Breton Women on the Cliff*, 185 x 350). There follows a transcription of the 1895 catalogue entries together with our provisional identifications so the reader can assess the situation for himself:

Paris	Edition	Present Catalogue
21. En chemin de fer	20	4?
22. Le mendiant	24	3
23. Le café	25	22
24. Le café	25	23
25. La jeune mère	10	15?
26. La jeune femme assise	10	1?
27. La jeune femme couchée	6	19
28. L'attente	5	—
29. Etude de nu	5	21?
30. L'idiote	2	79
31. La chanteuse	10	6?
Bretagne Paysage		
32. Arbres au soir	15	74
33. La maison triste	15	10
34. La pêche	15	27?
35. Les grands arbres	15	13
36. La ronde	15	2
37. L'orage	15	41?
38. L'entrée de la rivière	15	29/30?
39. Les collines	15	—
40. Les genêts	15	37
41. Le village	15	29
42. Le vallon	15	—
43. Les pommiers	5	39
44. Les bateaux	5	30
45. Le Pouldu	10	26/36/41?
46. Saint Maurice	15	25
47. Les sapins	15	40
48. La ferme	15	9
49. L'ouragan	10	14
50. Le soir (deux états)	—	68
51. La prairie	5	31?
52. La côte	5	42/69?
Divers		
53. Decoration de Bretagne	10	72
54. Decoration de Bretagne	10	73
55. Decoration de sapins	6	12?
56. L'enfant couché	20	—
57. L'enfant couché	2	—
58. Une enfant	10	65
59. L'enfant qui rit	10	—
60. La sournoise	10	—
61. Les ruisseuses	5	62
62. Saint Jean		81
63. 21 Planches tirées chacune à cinq épreuves...études pour les ruisseuses		44–61, 63, 64
64. Figure decorative	15	82?
65. Figure decorative	15	—
Paysage de Valmondois		
66. La peniche	10	17
67. Le chemin de hallage	10	18
68. Le débardeur	5	16
69. La gare de Valmondois	5	—
Portraits		
70. Port. de Maxime Froment	—	5
71. Port. de Johannes Delorme	—	—
72. Port. de M. Tanner	—	—
Gravure sur Bois de l'Ymagier		
73. Des Bretonnes		70
Lithographies		
74. Une femme couchée	—	84
75. Pêcheurs de goemons	10	85
76. La plaine	10	67
77. Jeune garcon	5	83?

Most of the major groups of prints by Seguin may be traced to logical sources. The most important of these belonged to Seguin's friend, the Irish artist who spent many years in Brittany and Paris, Roderick O'Conor (1860–1940). O'Conor's Seguins were sold at Hôtel Drouot (February 6–7, 1956), thirty-four prints being grouped in lots 66–69; these were bought in their entirety by Monsieur Pierre Fabius of Paris. Another large group was once

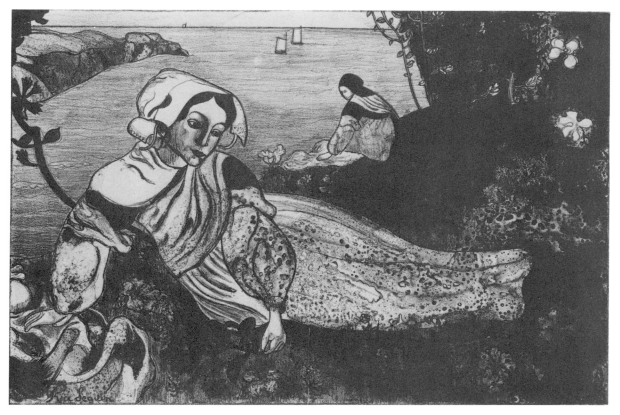

84D

in the possession of the son of the wood-engraver(?) Maurice Froment (see no. 5). These were purchased from Froment's son by the Bibliothèque Nationale around 1960. At the same time, the Ibels collection of zinc plates were reprinted by Malingue. During the 1950s and 1960s two other collections were formed. One, that of Eberhard Kornfeld of Bern, was simply culled from Paris dealers; the second, that of Samuel J. Wagstaff, Jr., was purchased from various sources including the collector Jacques Ulmann of Paris. The latter are stamped with a KW in a circle, a collector who has yet to be identified. Another group of prints, some of which have undoubtedly been dispersed, belongs to Mlle. Henriette Boutaric of Paris, heir to the collection of the Breton Nabis, Paul Sérusier (at whose home in Châteauneuf-de-Faou Seguin died in 1903). Monsieur and Madame Paul Prouté have also been collecting Seguin prints, several of which once belonged to the chronicler of 1890s printmaking, André Mellerio. Yet another interesting group of Seguins forms part of the Pont-Aven collections of Dr. and Madame René Guyot of Clohars-Carnoët (a small village between Pont-Aven and Le Pouldu). These works were gathered over the years but many came from an unidentified "collector of the Midi." The last collection of note was gathered by Maurice Malingue, Gauguin scholar and dealer; it seems that a number of these have passed onto collectors and museums (some are lost from sight and are only known to us from the 1960 notes of Sam Wagstaff), while others are now owned by his son, Stéphane Malingue. Interestingly, several of the most important of the Malingue holdings came from the painter-dealer Georges Chaudet, to whom both O'Conor and Seguin must have sold their work.

We have tried to be as specific as possible about the types of papers used by Seguin. Unfortunately, we gleaned no hints about chronology from this study, but the watermarks described may be of some help someday. Much of the various Arches paper used by Seguin was probably machine-made (despite the presence of chain and laid lines) and consequently appears like wove paper when viewed by reflected rather than transmitted light. This is particularly misleading when examining the prints in the Bibliothèque Nationale, Paris, for most are attached to their mats on all four sides. For the most part the frequently encountered "monogram watermark" takes the form of a script-like 'M' within a quarter-circle arc.

Seguin generally preferred a dark brown printing ink, noted in most cases. We assume that all except commissioned works were printed by the artist. To these he applied one, two, or three seals, probably wooden stamps much like those used by Gauguin in 1894 (see Field 1973, p. 16), and Emile Schuffenecker. The three stamps were printed in a variety of colors, occasionally in the image but usually in the lower right margin. They are a simple AS (used to sign a drawing as late as 1897), a more elaborate EAS (used to sign a drawing of 1891), and a fancy cachet that reads as a series of S's. The EAS stamp could mean "Epreuve Armand Seguin" or even "Ergasterium Armand Seguin" (Egastarium was the Nabis word for studio).

As usual, our measurements are in millimeters and are those of the platemarks unless otherwise noted, height before width. The abbreviated References will be found in full in the bibliography. Prints belonging to the Bibliothèque Nationale, Paris, are followed by a number in parentheses, indicating the position occupied in the large bound volume of Seguin's work in the Cabinet des Estampes.

Catalogue

Items with an asterisk are included in the exhibition.

1B

1. Nude in the Shadow of a Bat 1890
Femme nue à la chauve-souris
Etching, drypoint, and roulette
113 x 219
Signed in the plate, lower left: A. Seguin/1890
Reference: Barc de Boutteville 1895, no. 26(?)

A. Collection Bibliothèque Nationale, Paris (1)
Printed on white laid paper
Signed in pencil, lower right: A. Seguin
Brown AS stamp, lower right

*B. Collection Dr. & Mme. René Guyot, Clohars-Carnoët (Finistère)
Printed on white laid paper

C. Counterproof(?), formerly Collection Maurice Malingue, Paris

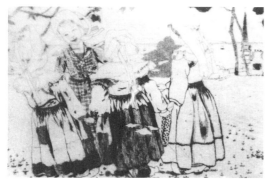

2A

2. La Ronde de Pont-Aven 1891
Etching, drypoint, and aquatint
105 x 185
Signed in the plate, lower right: Pont–Aven/1891
References: Barc de Boutteville 1895, no. 36; Pont–Aven 1961, no. 154

A. Collection Stéphane Malingue, Paris
Inscribed in pencil, lower right: à l'ami Chaudet/A. Seguin
Printed on cream laid paper
From the collection of Yves Delanoe

Georges Chaudet (1870–1899) was a painter, often in Brittany with Paul Sérusier and Georges Rasetti. He also acted as a dealer for Gauguin, Seguin, O'Conor, and probably many others.

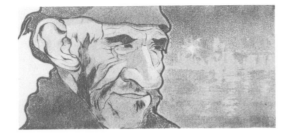

3A

3. **The Wanderer or Breton Fisherman** 1891
 Le mendiant
 Etching and aquatint
 72 x 141
 Reference: Barc de Boutteville 1895, no. 22

*A. Collection Pierre Fabius, Paris
 Inscribed in pencil, lower right: A l'ami O'Conor/A. Seguin 91
 Printed on laid paper, watermarked Crown with MA
 Vente O'Conor 1956, no. 69

B. Collection Paul Prouté, Paris
 Inscribed in pencil, lower right: A l'ami Forbes–Robertson/
 A. Seguin 91
 Printed on cream laid paper, watermarked Arches

C. Collection Stéphane Malingue, Paris

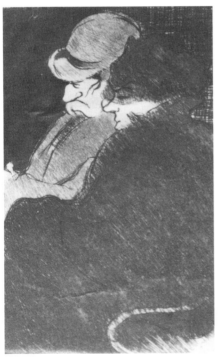

4A

4. **Seated Couple** 1891
 En chemin de fer
 Etching and drypoint
 112 x 72
 Reference: Barc de Boutteville 1895, no. 21(?)

A. Collection Pierre Fabius, Paris
 Inscribed in pencil, lower right: A l'ami O'Conor/A. Seguin 92
 Printed on cream laid paper; black ink brushed over the entire
 lower left corner
 Vente O'Conor 1956, no. 69

5A

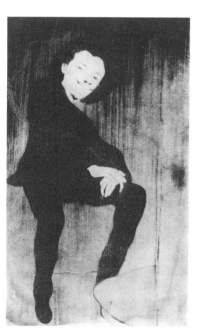

5C

5. Man with a Hat 1891
Homme au chapeau
Etching and aquatint
316 x 186
Reference: Barc de Boutteville 1895, no. 70; Pont-Aven 1961, no. 155(?)

First State: pure etched outline and curtain

A. Collection Bibliothèque Nationale, Paris(12)
Signed in pencil, lower right: AS/91
Printed on heavy, laid paper with pronounced weave-like texture; cut-off at bottom

Second State: addition of fine mesh cross-hatching over entire plate; the background, at least, has been aquatinted

B. Collection Bibliothèque National, Paris (13)
Signed in pencil, lower right: A. Seguin/91
Printed on cream laid paper with same weave-like texture; considerable wiping for contrast

C. Collection Bibliothèque National, Paris (14)
Inscribed in pencil, lower left: A l'ami Maurice/Armand Seguin/1892
Printed on cream laid paper with weave-like texture; wiped to accentuate the cigarette smoke
Green AS stamp, lower right

*D. Collection Pierre Fabius, Paris
Inscribed in pencil, at bottom: 1er état/Je vous enverrez les épreuves diffinitives dans quelques jours. Avez-vous reçu les . . . j'ai du vous les envoyez/A. Seguin
Printed on heavy, cream laid paper with same texture as many other proofs of this period; darkly inked but unevenly wiped

The inscription on impression C has led to the identification of the sitter as Maurice Froment (dates unknown), a Parisian printmaker whose work is virtually untraceable. According to Monsieur Fabius, most of the Seguin prints now owned by the Bibliothèque Nationale were purchased from Froment's son.

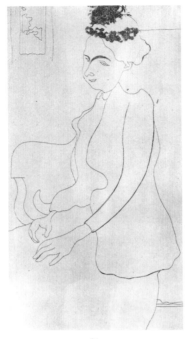

6A

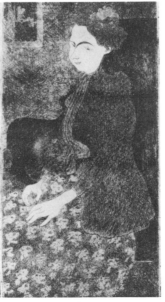

6D

6. Seated Woman with Feathered Hat　1891–92
Etching, drypoint, and stipple
215 x 110
Reference: Barc de Boutteville 1895, no. 31(?)
A preliminary watercolor drawing belongs to Monsieur Fabius

First State: pure etching; only the outlines and some shading of the hat

A. Collection Bibliothèque Nationale, Paris (10)
Printed on cream laid paper
Green AS stamp, lower right

Second State: heavily reworked in etching, drypoint, and stipple

B. Collection Bibliothèque Nationale, Paris (30)
Printed on heavy, laid paper; richly inked so that many features, other than face and hands, are obscured
Green AS stamp, lower right

C. Collection Pierre Fabius, Paris
Printed on cream laid paper; a pale and seemingly worn impression

D. Collection Museum of Modern Art, New York
Signed in pencil, lower right: A. Seguin
Printed on heavy, cream laid paper; unevenly wiped and printed
Green AS stamp, lower right
Collector's stamp, lower right: KW in circle

*E. Collection Samuel J. Wagstaff, Jr., New York
Printed on Japan paper; carefully wiped to reveal the patterns in the skirt and wall
Green AS stamp, lower right

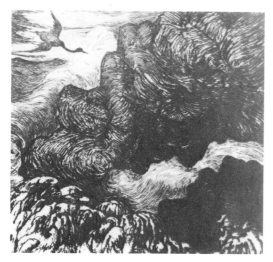

7A

7. **Swan Flying over Crashing Waves** ca. 1892
 Etching
 220 x 227 (rounded plate corners)

A. Collection Pierre Fabius, Paris
 Printed on cream laid paper; with extensive retroussage in
 the waves
 Vente O'Conor 1956, no. 69

8. **Two Swans Flying over the Sea** ca. 1892
 Etching
 182 x 264 (with rounded plate corners)

*A. Collection Eberhard Kornfeld, Bern
 Printed on cream laid paper, watermarked ARCHES

8A

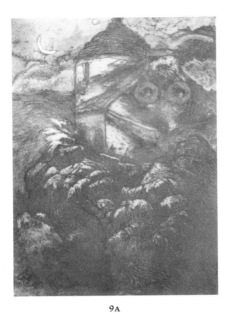

9A

9. The Farm ca. 1892
La ferme
Etching, aquatint, and open-bite
Reference: Barc de Boutteville 1895, no. 48

*A. Collection Pierre Fabius, Paris
Heavily printed on tan, wove paper
Vente O'Conor 1956, no. 69(?)

10. The Sad House ca. 1892
La maison triste
Etching and aquatint
223 x 250 (rounded plate corners)
Reference: Barc de Boutteville 1895, no. 33

*A. Collection Pierre Fabius, Paris
Impression on smooth, cream wove paper, printed in the same
shiny black ink as no. 11
Vente O'Conor 1956, no. 67(?)

10A

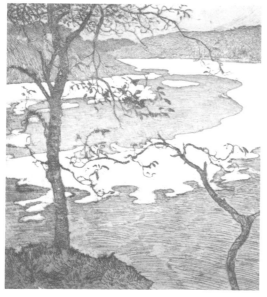

11A

11. Trees above the Estuary ca. 1892
Etching, aquatint, and open-bite
247 x 220

*A. Collection Pierre Fabius, Paris
Impression on heavy, cream wove paper; printed in the same
manner as no. 10 in a shiny ink on smooth paper
Vente O'Conor 1956, no. 66(?)

12. Pine Trees above the River ca. 1892
Etching, aquatint, and open-bite
160 x 198 (rounded plate corners)
Reference: Barc de Boutteville 1895, no. 55(?)

*A. Collection Samuel J. Wagstaff, Jr., New York
Inscribed with a yellow-penciled flower (the exact same monogram
as added to no. 70) and pencil signature (not in the artist's hand?),
lower left: Seguin (over Gauguin)
Printed on cream laid paper

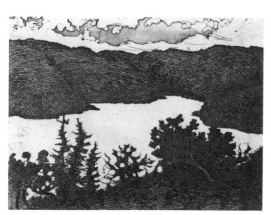

12A

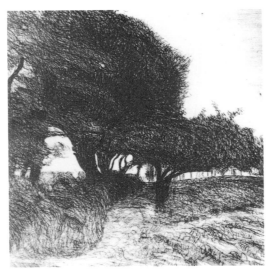

13A

13. The Majestic Trees ca. 1892–93
Les grands arbres
Etching and aquatint
335 x 306
Reference: Barc de Boutteville 1895, no. 35

*A. Collection Pierre Fabius, Paris
Printed in dark brown ink on a very heavy, cream wove paper
Vente O'Conor 1956, no. 66

B. Ex-collection Maurice Malingue, Paris (?)
From the artist/dealer, Georges Chaudet (1870–1899)

This work could be taken for one by Seguin's long-term friend, Roderick O'Conor (1860–1940), but we prefer to see it as a point of extreme rapprochement instead. Our opinion is supported by the fact that it was sold with a group of Seguin's prints in the O'Conor sale and that it can probably be identified as one of the prints exposed in Paris in 1895.

14. The Hurricane ca. 1893
L'ouragan
Etching, drypoint, and roulette
357 x 590
Reference: Barc de Boutteville 1895, no. 49

*A. Collection Pierre Fabius, Paris
Printed in brown ink on heavy, cream laid paper, watermarked MP
Red AS stamp, upper right
Vente O'Conor 1956, no. 66

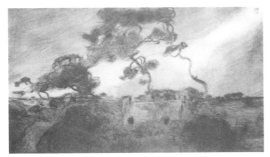

14A

15. Woman with two Children ca. 1892

La promenade; La jeune mère
Drypoint and roulette
160 x 64
Reference: Barc de Boutteville 1895, no. 25

First State: before the additions of the girl at the right, the house in the distance, and reworking in drypoint and roulette over the woman, water, distant trees, and the boy's coat and hat

A. Collection Pierre Fabius, Paris
Inscribed in pencil, lower right: 1er etat
Printed on heavy, laid paper
Beige AS stamp, lower right

Second State: with the additional work

B. Collection Bibliothèque Nationale, Paris (28)
Probably the same state and printing as C
Printed on ivory laid paper with wove surface texture
Brown AS stamp, lower right

C. Collection Pierre Fabius, Paris
Printed on heavy, tan laid paper with wove surface texture
Vente O'Conor 1956, no. 69

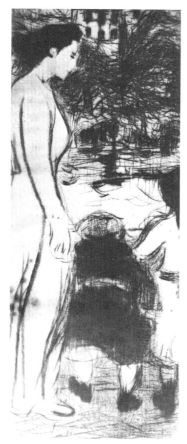

15c

16. The Steevador at Valmondois 1893

Le débardeur
Etching
162 x 277
Inscribed in plate, in reverse, lower left: 93 Valmondois/A. Seguin
Reference: Barc de Boutteville 1895, no. 68

A. Collection Pierre Fabius, Paris
Printed in dark brown ink on cream, laid paper with monogram watermark
Red AS stamp, lower right
Vente O'Conor 1956, no. 68

B. Collection Paul Prouté, Paris
Printed on laid paper with wove texture, watermarked Arches
Red AS stamp, lower right; possibly the same impression as C

C. Ex-Collection Paule Cailac, Paris
Impression on thin, wove paper, rather worn

D. Collection Dr. & Mme. René Guyot, Clohars-Carnoët
Printed on cream laid paper, watermarked MBM

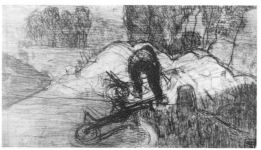

16A

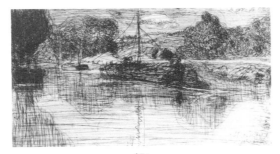

17A

17. The Barge at Valmondois 1893

La peniche
Etching, drypoint, and roulette
160 x 275
Inscribed in plate, in reverse, lower right: 93 A. Seguin, Valmondois
Reference: Barc de Boutteville 1895, no. 66

*A. Collection Pierre Fabius, Paris
Printed in dark brown ink on cream laid paper with monogram watermark
Vente O'Conor 1956, no. 68

B. Collection Pierre Fabius, Paris
Printed in dark brown ink on cream laid paper; more carefully inked and printed than A

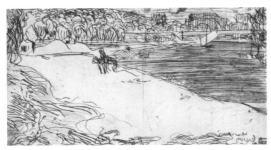

18A

18. The Tow Path, Valmondois 1893

Le chemin de hallage, Valmondois
Etching
162 x 277
Inscribed in the plate, in reverse, lower right: 93 Valmondois/ A. Seguin
Reference: Barc de Boutteville 1895, no. 67

A. Collection Pierre Fabius, Paris
Printed in dark brown ink on heavy laid paper, watermarked Arches
Red AS stamp, lower right
Vente O'Conor 1956, no. 68

B. Collection Eberhard Kornfeld, Bern
Signed in pencil, lower right: A. Seguin
Printed on tan laid paper, watermarked MBM
Small unidentified mark, plus maroon AS and brown EAS stamps at lower right

C. Collection Stéphane Malingue, Paris

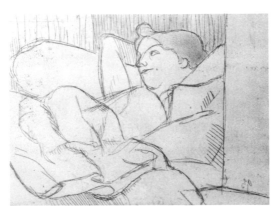

19M

19. Young Woman in Bed 1893

Jeune femme couchée
Etching, roulette, and open-bite
138 x 179 (with nick out of left edge of plate)
Inscribed in plate, in reverse, lower right: 93
Reference: Barc de Boutteville 1895, no. 27; Pont-Aven 1961, no. 159

A. Collection Pierre Fabius, Paris
Printed in dark brown ink on heavy, cream laid paper
Vente O'Conor 1956, no. 69

B. Collection Stéphane Malingue, Paris
Printed on cream laid paper, watermarked MBM
Green AS stamp, lower right

 *Malingue Restrike Edition

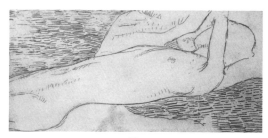

20M

20. Reclining Nude ca. 1893
 Nu
 Etching
 117 x 225
 Malingue Restrike Edition

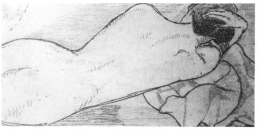

21A

21. Reclining Nude with Chignon ca. 1893
 Etching, roulette, open-bite
 114 x 217
 Reference: Barc de Boutteville 1895, no. 29(?)

*A. Collection Samuel J. Wagstaff, Jr., New York
 Printed on cream laid paper, watermarked with a monogram

 B. Collection Jean Chauvelin, Paris
 AS stamp, lower right

 Malingue Restrike Edition

 Traces of another image, a head of a Breton woman, can be dimly
 perceived "beneath" the present image. See no. 59.

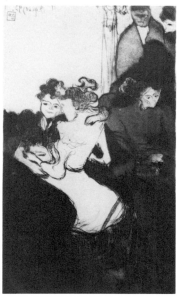

22B

22. The Bar 1893
 Le bar
 Etching, aquatint, soft-ground etching, open-bite, and roulette
 395 x 230
 Signed in plate, in reverse, upper left: A Seguin 93
 Reference: Barc de Boutteville 1895, no. 23 or 24; Pont-Aven
 1961, no. 168; Mannheim 1963, no. 238

 A. Collection Bibliothèque Nationale, Paris (29)
 Impression in dark brown ink on white laid paper not much
 different from that used for impressions of no. 5
 Brown AS stamp, upper left

*B. Collection Pierre Fabius, Paris
 Impression in dark brown on cream laid paper
 Maroon AS stamp, upper left

 C. Collection Mlle. Henriette Boutaric, Paris (?)

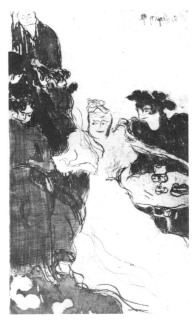

23A

23. The Cafe 1893

Le café
Etching, roulette, and open-bite
393 x 230
Signed in plate, in reverse, upper right: A Seguin 93.
References: Barc de Boutteville 1895, no. 23 or 24; Mannheim 1963, no. 241; London 1966, no. 171

A. Collection Pierre Fabius, Paris
Printed in dark brown ink on cream, wove paper
Vente O'Conor 1956, no. 24

*B. Collection Samuel J. Wagstaff, Jr., New York
Printed in dark brown on cream laid paper; plate tone
Red AS stamp upper right and tan AS stamp lower right

C. Collection Kunsthalle, Bremen

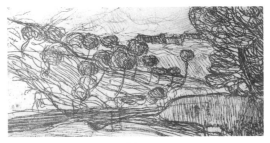

24M

24. The Waterside Trees ca. 1893

Etching
85/88 x 156
So far as we know, this etching exists only in modern impressions.

Malingue Restrike Edition

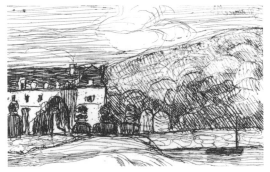

25A

25. Saint Maurice 1893

Etching
105 x 164
Inscribed in plate, in reverse, upper right: St. Maurice 93
Reference: Barc de Boutteville 1895, no. 46

*A. Collection Samuel J. Wagstaff, Jr., New York
Printed in dark brown ink on tan laid paper, watermarked ARCHES
Ochre AS stamp, lower right: KW in circle collector's mark, lower right

Malingue Restrike Edition

Saint Maurice, with its chateau (destroyed during World War II), is a small bend in the River Laïta not more than three miles upstream from Le Pouldu.

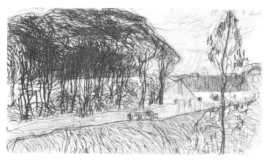

26A

26. The Trees beyond the Road at Le Pouldu 1893
Etching and roulette
178 x 300
Inscribed in plate, in reverse, upper right: Pouldu A. Seguin 93

A. Collection Bibliothèque Nationale, Paris (17)
Printed in dark brown ink on ivory, laid paper
Green AS stamp, lower right

B. Ex-collection Marcel LeComte, Paris
Inscribed in pencil at top: à Ibels/A. Seguin
Printed on Van Gelder, laid paper, watermarked Hollande

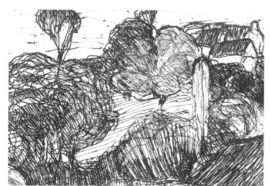

27D

27. Fishing 1893
La pêche
177 x 298/302 (irregular; the reversed '12' at the upper left indicates that Seguin used the verso of one of his plates for this work)
Inscribed in the plate, in reverse, at the lower left: AS/Juillet 93
References: Barc de Boutteville 1895, no. 34(?)

A. Collection Pierre Fabius, Paris
Printed on cream, laid paper, watermarked Arches
Vente O'Conor 1956, no. 68

B. Collection Eberhard Kornfeld, Bern
On same paper
Ochre AS and Maroon EAS stamps, lower right

*C. Collection Samuel J. Wagstaff, Jr., New York
On same paper, with same stamps as 'B'
Signed in pencil, lower left: Seguin (artist's hand?)
Verso: Collector's stamp: Simone, Paris

D. Collection Samuel J. Wagstaff, Jr., New York
Printed more heavily and in a browner ink on tan laid paper, watermarked ARCHES
Collector's mark, lower right: KW in a circle
Signed in pencil, lower right: A Seguin
Ochre AS and maroon EAS stamps, lower right

28. The Small Landscape 1893
Petit paysage
Etching
77 x 107
Inscribed in plate, in reverse, upper left: 93

A. Collection Bibliothèque Nationale, Paris (4)
Printed in dark brown ink on cream laid paper
Beige AS stamp, lower right

Malingue Restrike Edition

28A

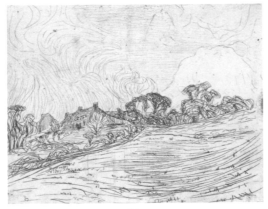

29A

29. The House under Restless Skies ca. 1893

Le village
Etching
230 x 285
Reference: Barc de Boutteville 1895, no. 41

*A. Collection Pierre Fabius, Paris (2 impressions)
Printed on cream laid paper, watermarked ARCHES; one, a
well-inked impression with smudge on right border
Vente O'Conor 1956, no. 68

B. Collection Stéphane Malingue, Paris
Printed on cream laid paper, watermarked ARCHES; stained
From the collection of Georges Chaudet

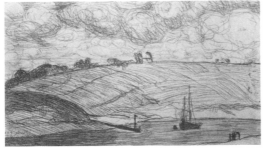

30B

30. The Mooring 1893

L'entrée de la rivière
Etching
181 x 303 (rounded plate corners)
Inscribed in plate, in reverse, lower left: Juillet (or Pouldu?) 93
Reference: Barc de Boutteville 1895, no. 38(?); London 1966,
no. 173

A. Collection Bibliothèque Nationale, Paris (26)
Printed on cream, laid paper with wove texture, probably the
same as B & C

B. Collection Pierre Fabius, Paris
Inscribed in pencil, lower right: à Monsieur Beltrand/en signe
d'amitié/A Seguin.
Printed on medium, cream laid paper, watermarked Arches
Red AS and blue SSS stamps, lower right

C. Collection Eberhard Kornfeld, Bern
Printed on laid paper, watermarked Arches (script)

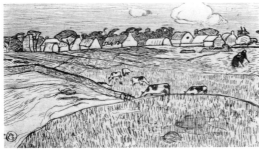

31A

31. Women and Cows in the Fields, Brittany 1893

Etching
182 x 300 (rounded plate corners)
Signed in plate, in reverse, lower left: AS 93
Reference: Barc de Boutteville 1895, no. 51(?)

A. Collection Bibliothèque Nationale, Paris (22)
Printed in dark brown ink on machine-made, ivory laid paper
Red SSSS stamp, lower right

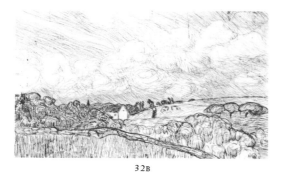

32B

32. Farmlands with Cows 1893
Etching
182 x 303 (rounded plate corners)
Signed in plate, in reverse, lower right: AS 93
Reference: Pont-Aven 1961, no. 167(?); Basel 1975, no. 103

*A. Collection Eberhard Kornfeld, Bern
Printed on white laid paper
Red AS and gray-green EAS stamps, lower right

B. Collection Mlle. Henriette Boutaric(?)

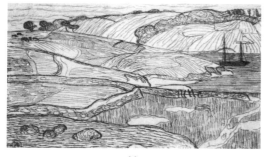

33A

33. Landscape with Horses and Sailboat 1893
Etching
184 x 295 (rounded plate corners)
Signed in plate, in reverse, lower left: AS 93

*A. Collection Samuel J. Wagstaff, Jr., New York
Inscribed in pencil, lower right: AS
Printed on tan laid paper
Green AS stamp, lower right

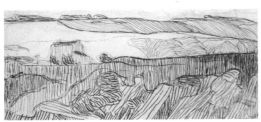

34M

34. Striped Landscape ca. 1893
Etching
91 x 195

Malingue Restrike Edition

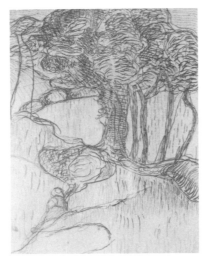

35M

35. Landscape with Figure and large Tree ca. 1893
Paysage de Pont-Aven
Etching
164 x 120
Reference: Quimper 1978, no. 82 (recent impression)

Malingue Restrike Edition

36. Landscape, Le Pouldu ca. 1893
Paysage au Pouldu
Etching
180 x 300
Reference: Barc de Boutteville 185, no. 45(?); Pont-Aven 1961, no. 161

A. Collection Stéphane Malingue, Paris
Printed on thin, laid paper
From the collection of Georges Chaudet

*B. Collection Eberhard Kornfeld, Bern
Printed on thin, laid paper, watermarked MBM
Inscribed in red crayon, upper right: 61; and in pencil, lower right: N66
Brown EAS stamp and red & blue SSSS stamp, lower right

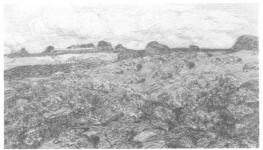

36B

37A

37. Landscape with Bushes, Le Pouldu 1893
Les genêts
Etching
182 x 303
Signed in the plate, in reverse, upper left: A. Seguin/Pouldu
References: Barc de Boutteville 1895, no. 40(?); London 1966, no. 176

A. Collection Eberhard Kornfeld, Bern
Printed in black-brown ink on white laid paper, watermarked Arches
Red AS and green EAS stamps, lower right

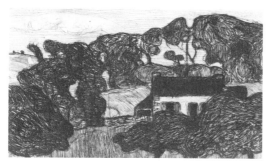

38A

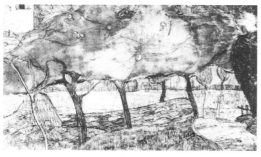

39A

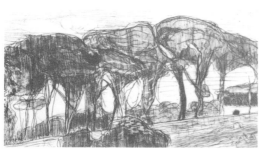

40B

38. Farm House Surrounded by Trees ca. 1893
Etching
183 x 305 (rounded plate corners)
Reference: London 1966, no. 175

A. Collection Art Institute of Chicago (Gift of Eberhard Kornfeld)
Printed in brown ink on laid paper
Green AS stamp, lower right

B. Collection Eberhard Kornfeld, Bern
Inscribed in pencil, lower left (by the artist?): 11
Printed on laid paper, watermarked Arches
Brown AS stamp, lower right

*C. Collection Samuel J. Wagstaff, Jr., New York
Slightly worn and unevenly printed impression in brown ink
printed on laid paper, watermarked ARCHES
Tan AS stamp, lower right

D. Collection Jean Chauvelin, Paris

Probably executed from the same motif and at the same time as the
oil, **Les Deux Chaumières**, ca. 1893, exhibited in London 1966,
no. 167.

39. The Apple Trees at Le Pouldu ca. 1893
Les pommiers
Etching and aquatint
179 x 298
Inscribed in plate, in reverse, lower right: Pouldu/A. Seguin
Reference: Barc de Boutteville 1895, no. 43

A. Collection Stéphane Malingue, Paris
Printed on cream laid paper, watermarked Arches
Green AS stamp, lower right

*B. Collection Dr. & Mme. René Guyot, Clohars-Carnoët
Printed on cream laid paper, watermarked MBM
Green AS stamp, lower right

40. The Pine Trees 1893
Les sapins
Etching and roulette
182 x 302
Inscribed in plate, in reverse, lower right: A. Seguin 93
Reference: Barc de Boutteville 1895, no. 47; Hofstätter 1968, p. 27

A. Collection Bibliothèque Nationale, Paris (16)
Printed on tan, machine-made laid paper

*B. Collection Pierre Fabius, Paris
Printed on cream laid paper, watermarked Arches
Vente O'Conor 1956, no. 69(?)

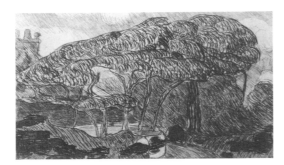

41A

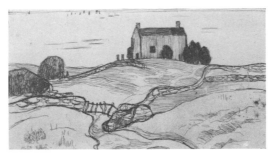

42B

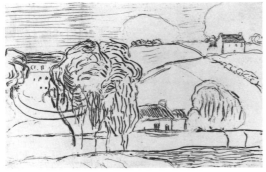

43A

41. The Billowing Trees 1893

L'orage (?)
Etching, drypoint, and soft-ground
181 x 298
Inscribed lightly in plate, in reverse, lower left:
A. Seguin 93/Pouldu
Reference: Barc de Boutteville 1895, no. 37(?)

*A. Collection Samuel J. Wagstaff, Jr., New York
Printed on cream laid paper, watermarked ARCHES
Yellow AS and gold EAS stamps, lower right

 B. Collection Samuel Josefowitz, Lausanne
Printed on cream laid paper, watermarked Arches (script)
AS and EAS stamps, lower right

42. House on a Hilltop overlooking the Sea 1893

La maison du pendu
Etching
182 x 302
Inscribed in plate, in reverse, lower left: Juillet 93
Reference: Pont-Aven 1961, no. 157; London 1966, no. 172

 A. Collection Bibliothèque Nationale, Paris (15)
Printed on machine-made, laid paper

*B. Collection Eberhard Kornfeld, Bern
Printed on laid paper watermarked Arches
Inscribed in pencil, lower right: 11 epreuves; and at the
lower left: 7
Green SSSS stamp, lower right

 C. Collection Eberhard Kornfeld, Bern
Printed on the same paper as B
Inscribed in pencil, upper right: A. Seguin/à l'ami Ibels

The house is the same as that painted by Charles Filiger in 1890 or
1891, *La maison du pendu (paysage parabolique)*, and by
Gauguin in *La maison isolée* of 1889 (Wildenstein 364), *La
maison du pendu* and *La perte du pucelage* both of 1890
(W. 395 & 412). See G. Lacambre's essay under entry 35 in
l'Ecole de Pont-Aven, Quimper, Musée des Beaux-Arts,
July–October 1978.

43. Willow Trees by the River ca. 1893

Etching
169 x 258

*A. Collection Samuel J. Wagstaff, Jr., New York
Printed on Japan paper
Gray AS and red SSSS stamps, lower right
Collector's mark, lower right: KW in circle

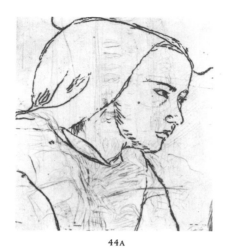

44A

44. Head of a Breton Woman, Facing Right 1893–94
Etching
114 x 93

*A. Collection Samuel J. Wagstaff, Jr., New York
Printed in dark brown ink on cream laid paper, watermarked
with monogram
Signed in pencil, lower right: A Seguin (by the artist?)
Red EAS stamp, lower right
Collector's stamp, lower right: KW in a circle

Malingue Restrike Edition

A burnished landscape drawing is barely visible in 'A' but no
longer in the 1960 reprints.

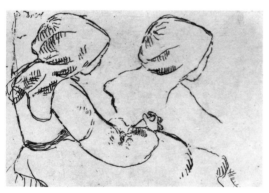

45A

45. Two Seated Breton Women 1893–94
Deux Bretonnes assises
Etching
132 x 183
Inscribed, in reverse, upper left: vert

A. Collection Bibliothèque Nationale, Paris (11)
Printed in dark brown ink on thin, buff laid paper
Signed in blue crayon, lower right: A. Seguin
Green AS stamp, lower right

Malingue Restrike Edition

46A

46. Profiles of Two Breton Women 1893–94
Etching
115 x 170

A. Collection Stéphane Malingue, Paris
A recent impression on wove paper. This was one of the irreparable
plates among those found at the house of H. G. Ibels; accordingly,
it was not included in the edition of reprints.

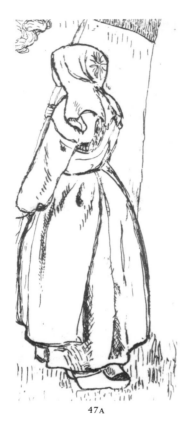

47A

48M

47. Breton Woman with Gathered Cap, Seen from the back, full length 1893–94
Etching
415 x 170

*A. Collection Paul Prouté, Paris
Printed on cream laid paper, watermarked Arches (script)
Green AS stamp, lower right

48. Breton Woman with Gathered Cap, Overlooking the Fields
1893–94
Paysanne en coiffe de travail
Etching
162 x 153
Inscribed in plate, in reverse, with color notations, on coiffe:
violet; and on vest: vert
Reference: Quimper 1978, no. 77 (recent impression)

A & B. Collection Dr. & Mme. René Guyot, Clohars-Carnoët
Both proofs on laid paper, watermarked Arches
Brown and green AS stamps, lower right

Malingue Restrike Edition

49M

49. Breton Woman with Cap, Seen from Back　1893–94

Femme en coiffe, de dos

Etching

115 x 112

Reference: Quimper 1978, no. 78 (recent impression)

Malingue Restrike Edition

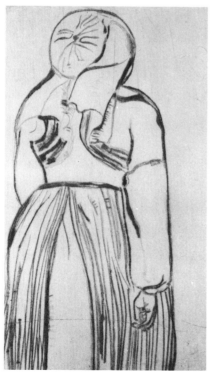

50A

50. Breton Woman with Cap, Seen from Back, three-quarter length
1893–94

Femme en coiffe, de dos

Fine roulette and drypoint(?)

171 x 100

*A. Collection Samuel J. Wagstaff, Jr., New York

　Printed on cream laid paper, watermarked ARCHES

　Malingue Restrike Edition

　Traces of a burnished landscape are visible in 'A'.

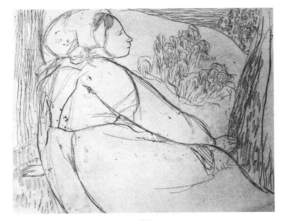

51M

51. Resting Woman holding a Bundle of Flax 1893–94
Jeune paysanne assise, de profil
Etching
170 x 192
Reference: Quimper 1978, no. 79 (recent impression?)

Malingue Restrike Edition

Traces of a burnished drawing still visible in 1960 impressions.

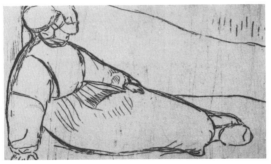

52A

52. Breton Woman Reclining by a Tree 1893–94
Femme assise
Etching
89 x 142

A. Collection Pierre Fabius, Paris
Printed on cream laid paper, with a large crown watermark
Inscribed in pencil, lower right: en signe d'amitié
Red AS and green SSSS stamps, lower right
Vente O'Conor 1956, no. 67

B. Collection Dr. & Mme. René Guyot, Clohars-Carnoët
Printed on buff laid paper

Malingue Restrike Edition

53A

53. Breton Woman leaning against a Tree 1893–94
Etching
114 x 187

A. Collection Stéphane Malingue, Paris
Probably a late impression on the same paper used for the reprints
of ca. 1960

54M

55M

54. Profile of a Seated Woman 1893–94
Femme assise
Etching
182 x 85

Malingue Restrike Edition

55. Decorative Figure: Breton Woman holding bundle of Flax
1893–94
Etching
181 x 85
Inscribed with color notations in the plate, in reverse: blanc, jaune
vert, violet, noir
Quimper 1978, no. 80 (recent impression)

Malingue Restrike Edition

52

56M

56. Seated Breton Woman with Black Hood (horizontal) 1893–94
 Femme assise
 Etching
 113 x 179

 Malingue Restrike Edition

57M

57. Seated Breton Woman with Black Hood (vertical) 1893–94
 Femme assise
 Etching
 184 x 86 (rounded plate corners)

A. Collection Fondation Jacques Doucet, Bibliothèque d'Art
 et d'Archéologie, Paris
 Printed on cream laid paper
 Beige AS and green EAS stamps, lower right

 Malingue Restrike Edition

 Traces of a burnished drawing are visible in 'A'.

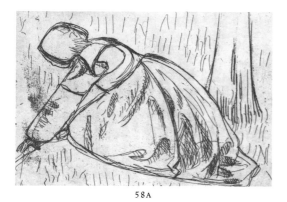

58A

58. Breton Woman Kneeling at work before a Tree 1893–94
La glaneuse
Etching
180 x 249 (left plate corners rounded)

*A. Collection Samuel J. Wagstaff, Jr., New York
Printed on tan laid paper
Signed in pencil, lower right: AS & A. Seguin (artist's hand?)
Inscribed in pencil, lower center: La Glaneuse/ . . . 1907/Le Garrec
Collector's mark, lower right: KW in a circle
Red AS and blue EAS stamps, lower right

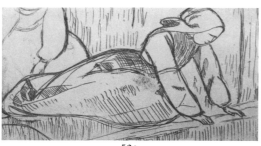

59A

59. Two Breton Women at Work 1893–94
Etching
140 x 251

A. Collection Pierre Fabius, Paris
Printed on heavy, cream laid paper, with a large crown watermark

B. Collection Eberhard Kornfeld, Bern
Printed on tan laid paper, watermarked MBM
Green AS stamp, lower right

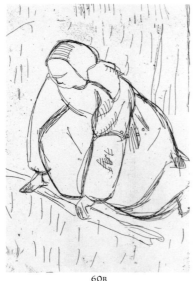

60B

60. Breton Woman at Work (cropped at right) 1893–94
Etching
182 x 124

A. Collection Fondation Jacques Doucet, Bibliothèque d'Art et
d'Archéologie, Paris
Printed on white laid paper, watermarked VAN GELDER
Gray AS and brown EAS stamps, lower right

*B. Collection Samuel J. Wagstaff, Jr., New York
Printed in dark brown ink on cream laid paper, watermarked
with monogram
Signed in pencil, lower right: A. Seguin (artist's hand?)/
La Glaneuse(?)
Green AS stamp, lower right
Collector's mark, lower right: KW in circle

Malingue Restrike Edition

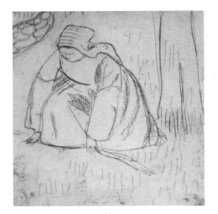

61M

61. Breton Woman Kneeling at Work, with Wall and Tree 1893–94

Etching

182 x 173

Malingue Restrike Edition

This plate was probably part of a larger plate that included the preceding work (left half). The entire plate would then have measured 182 x 298, the exact size of the standard copperplates employed for some of the presumedly earlier landscapes (see nos. 26, 27, 30, 31, 32, 36, 37, 38, 39, 40, 41, and 42).

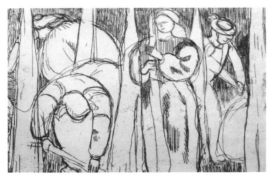

62B

62. The Flax Gatherers 1893–94

Les ruisseuses

Etching

159 x 229 (223 across top)

References: Barc de Boutteville 1895, no. 61(?); Chassé 1921, p. 55

A. Collection Paul Prouté, Paris
Printed on cream laid paper, watermarked MBM
Signed in pencil, lower right: A. Seguin
Green AS stamp, lower right
From the André Mellerio Collection

*B. Collection Samuel J. Wagstaff, Jr., New York
Printed on cream laid paper, watermarked with a monogram
Traces of a burnished drawing are still visible.

63B

63. Small Breton Study 1893–94

Etude bretonne

Etching and aquatint

90 x 81

A. Collection Bibliothèque Nationale, Paris (3)
Printed in dark brown ink on cream laid paper
Blue and yellow AS stamp, lower right

B. Collection Pierre Fabius, Paris
Printed on cream laid paper, watermarked with a monogram
Vente O'Conor 1956, no. 67

Malingue Restrike Edition

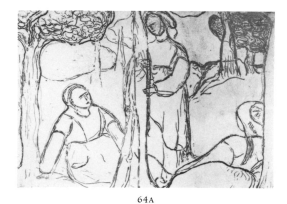

64A

64. Three Breton Women Resting after Work 1893–94
Etching
300 x 429

A. Collection Pierre Fabius, Paris
Printed on coarse, cream laid paper, watermarked with monogram
Vente O'Conor 1956, no. 67

65B

65. Young Breton Woman adjusting her Hat 1893-94
Buste de fillette bretonne
Etching
169 x 180
Reference: Barc de Boutteville 1895, no. 58

*A. Collection Samuel J. Wagstaff, Jr., New York
Printed in brown on cream laid paper
Signed in pencil, lower left: Seguin (artist's hand?)
Blue AS stamp, lower right

B. Unknown collection (from photograph)
Impression with swirled wiping of plate

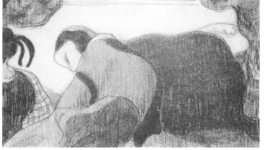

66A

66. The Daydream 1893
Lithograph
137 x 220 (image)
Signed in plate (or stone), lower center: A. Seguin '93

*A. Collection Pierre Fabius, Paris
Printed in brown ink on imitation Japan paper
Vente O'Conor 1956, no. 69

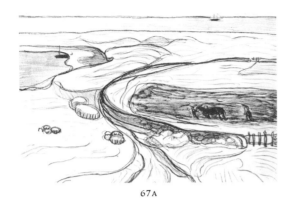

67A

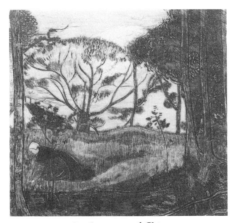

68 Art Institute of Chicago

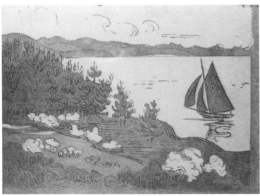

*69A

67. The Plain 1893
La plaine
Lithograph
228 x 311
Signed in stone, in reverse, lower left: A. Seguin, 1893
Reference: Barc de Boutteville 1895, no. 76; Hofstätter 1968, p. 26

A. Collection Bibliothèque Nationale, Paris (21)
Printed on wove paper

*B. Collection Museum of Fine Arts, Boston
Printed on wove paper

68. Evening 1894
Le soir or La glaneuse
Etching, aquatint, roulette (on plate with beveled edges), printed in brown ink
232 x 230
Published in *l'Estampe originale*, Album no. 7, Paris, July–September, 1894, in an edition of 100
Signed in pencil, lower left: A. Seguin; with blind stamp of *l'Estampe originale*, lower right
References: Barc de Boutteville 1895, no. 50; Vente O'Conor 1956, no. 66; Pont-Aven 1961, no. 166; Mannheim 1963, no. 238; London 1966, no. 177; Stein 1970, no. 79; Quimper 1978, no. 83

A. Collection Bibliothèque Nationale, Paris (25)
Proof impression on wove paper; possible retouches in white
Inscribed in pencil, lower right: à Filiger

Other impressions from *l'Estampe originale* may be found in the collections of Pierre Fabius, Paris; Paul Prouté, Paris; Dr. Paressant, Nantes, Stéphane Malingue, Paris; La Fondation Jacques Doucet, Bibliothèque d'Art et d'Archéologie, Paris; Samuel Josefowitz, Lausanne; University of Glasgow (collection J. A. McN. Whistler);
*Samuel J. Wagstaff, Jr., New York; The Museum of Fine Arts, Boston; The Art Institute of Chicago; etc.

An additional state may have existed since two states are mentioned under "Le Soir" in Seguin's exhibition at Le Barc de Boutteville. The identification of the present subject is based on the O'Conor-Fabius impression which is signed, "Le Soir." The motif of this etching is identical with that painted in the spring of 1894 by Paul Gauguin, *Farm in Brittany* (W. 372, incorrectly assigned to 1889), collection Emil G. Bührle, Switzerland.

69. Sailboat on a Mountain Lake 1894–95
La côte
Etching and open-bite aquatint
223 x 289
Reference: Barc de Boutteville 1895, no. 52

*A. Collection Museum of Fine Arts, Boston
Printed in brown ink on cream laid paper, watermarked with crown and letters VGL

B. Collection Eberhard Kornfeld, Bern
Printed in brown ink on a heavy, fine wove paper

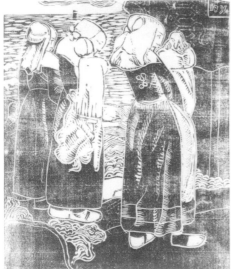

70A

Les bretonnes
Woodcut
220 x 186

References: Barc de Boutteville 1895, no. 73; Paris 1950, no. 222; Paris 1960, no. 130; London 1966, no. 187; Bremen 1967, no. 218 (as Emile Bernard); Basel 1975, nos. 100 & 101 (as Emile Bernard)

First State: Before the addition of the (white-line) monogram at the lower right, of the lines behind the tree trunk, and a crack in the foliage at the upper right; but without the verses by Charles Morice, "A Paul Gauguin," dated 21 November 1894, set in letterpress above the woodcut. It is not clear whether this was published or simply a special edition pulled for Gauguin and Morice. In any case, the only impressions known to us all have handwritten dedications from Gauguin to his friends.

A. Collection Fondation Jacques Doucet, Bibliothèque d'Art et d'Archéologie, Paris
 Printed in brown on cream laid paper, watermarked with a cock over the letters VIGILANTIA/1449
 Inscribed in ink at bottom: Dolent tane! Parau oe—no tea? Mata oe parau/P. Gauguin

B. Whereabouts Unknown
 Printed in brown ink on cream laid paper, watermarked as 'A' above
 Inscribed in ink below: Maufra Arofa oe/P. Gauguin
 Ex-collection Maxime Maufra

C. Collection Mlle. Henriette Boutaric, Paris
 Printed in brown ink
 Inscribed in ink below: Serusier tane! Nafea oe naere/na te ferua no moe/P. Gauguin

D. Collection Eberhard Kornfeld, Bern
 Printed in brown ink on laid paper
 Inscribed with dedication to Stéphane Mallarmé

E. Collection British Museum (Campbell Dodgson)
 Printed in brown ink on laid paper
 Inscribed in ink below: Vahine montorient! parahi muri muri i te/fenua noa noa/Paul Gauguin

Second State: With additional work but minus the Morice poem. This state was published in the periodical, l'Ymagier (edited and published by Remy de Gourmont, friend of many of the painters of the Nabis and Pont–Aven circles), No. 2, January 1895, and indexed as "A. Seguin. Bretonnes, bois original." Bock and Müller (in Bremen 1967) and Kornfeld (in Basel 1975) both argue that the monogram should be read "EB" and therefore this woodcut should be regarded as the work of Emile Bernard. We can hardly support such a contention. Not only was Bernard in Cairo at the time (his work was confined to lithography despite the woodcut-like appearance of the images he sent to l'Ymagier), but it is virtually unthinkable that he could have been persuaded to execute an image that would celebrate his rival, Paul Gauguin. Furthermore, the figure style is not at all consonant with Bernard's far more decorative conceptions of the human figure. In fact, it is

almost identical with those types Seguin himself had etched in Brittany during 1893–94 (see nos. 44—65). The manner in which the limbs are rather awkwardly differentiated from the mass of the bodies, the rather sparse and uninflected modeling are both far closer to Seguin than to Bernard, as is the reciprocity of the black and white line technique (see no. 86). Finally it is to be noted that the seeming "EB" monogram (which we cannot decipher) may be found on at least one other of Seguin's works (see no. 12).

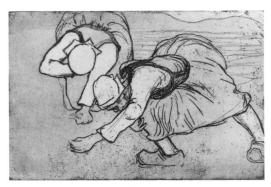

71A

71. Breton Women Planting 1894–95
Etching and aquatint
183 x 276
References: London 1966, no. 181; Basel 1975, no. 102

*A. Collection Eberhard Kornfeld, Bern
Printed on heavy wove paper

The source for this etching was almost surely Jean-Francois Millet's *Les Glaneuses* of 1857 (or the etching of the same subject, Delteil 12). In a letter to O'Conor written in 1897, Seguin speaks of a Millet drawing he saw in Paris—that here was "la source de toute la synthèse, notamment pour les terrains de Van Gogh et de Gauguin" (quoted by Denys Sutton in London, 1966, p. 7). Nevertheless, the style and technique of Seguin's etching and the lack of any etched work assignable to 1897 argue for the date we have assigned above.

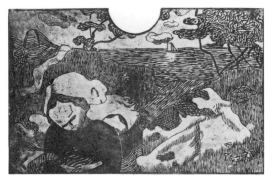

72A

72. A Summer's Day ca. 1894
Decoration de Bretagne
Etching (sugar-lift aquatint?)
245 x 378 (center top of plate with semi-circular cutout)
References: Barc de Boutteville 1895, no. 53 or 54; Hofstätter 1965, figure 7 (wrongly described as a zincograph); London 1966, no. 174; Jaworska 1972, p. 147

A. Collection Bibliothèque Nationale, Paris (23)
Printed in heavy black ink on cream wove paper
Green EAS stamp, lower right

B. Collection Pierre Fabius, Paris
Printed in heavy black ink on cream laid paper, watermarked with monogram
Red AS stamp, lower right
Vente O'Conor 1956, no. 68

*C. Collection Paul Prouté, Paris
Printed on thin Japan paper; a weaker impression

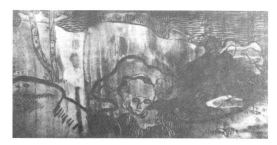

73A

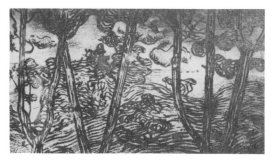

74A

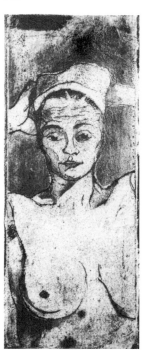

75M

73. Breton Woman by the Sea ca. 1894
Decoration de Bretagne
Etching (sugar-lift aquatint?)
184 x 349
References: Barc de Boutteville 1895, no. 53 or 54

A. Collection Pierre Fabius, Paris
Printed in heavy black ink on a machine-made, laid paper
Red AS stamp, lower right
Vente O'Conor 1956, no. 68

B. Collection Stéphane Malingue, Paris
Printed on medium heavy, laid paper, watermarked ARCHES
Green AS stamp, lower right

C. Collection Eberhard Kornfeld, Bern
Printed on medium heavy, cream laid paper, watermarked
ARCHES
Gray EAS and green AS stamps, upper left

*D. Collection Samuel J. Wagstaff, Jr., New York
Printed in heavy, warm black ink on cream laid paper,
watermarked ARCHES
Green and red AS stamps, lower right

The finger prints on this plate recall those found on *Femme aux
Figues* (no. 75). All four impressions display the identical streaks
and prints, probably indicating a faulty etching ground.

74. Trees at Night ca. 1894
Arbres au soir
Etching (sugar-lift aquatint?)
165 x 249
Reference: Barc de Boutteville 1895, no. 32

A. Collection Pierre Fabius, Paris
Printed on cream laid paper, watermarked ARCHES
Inscribed, in pencil: Arbres au soir
Red AS stamp, lower right
Vente O'Conor 1956, no. 68

75. Nude with Hands behind her Head (vertical) ca. 1894
Etching and open-bite aquatint
163 x 62
Reference: Pont–Aven 1961, no. 177

A. Collection Stéphane Malingue, Paris
Printed on cream laid paper, watermarked MBM
Green AS and red EAS stamps, lower right
From the collection of Georges Chaudet

B. Collection Dr. & Mme. René Guyot, Clohars-Carnoët
Printed on same sheet of buff laid paper with an impression of
no. 76
Yellow AS and blue SSSS stamps, lower right

Malingue Restrike Edition

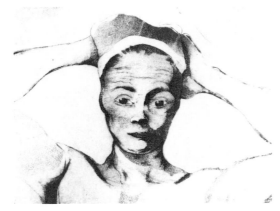

76A

76. Nude with Hands behind her Head (horizontal) 1894–95
Etude
Etching and aquatint
82 x 105
Published in *l'Ymagier*, No. 3, April, 1895
Reference: London 1966, no. 180

First State: Pure aquatint

*A. Collection Samuel J. Wagstaff, Jr., New York
Printed on medium heavy, cream laid paper
Inscribed in ink, lower right: 1º Etat/A. Seg.
Red EAS stamp, lower right

Second State: With the addition of further aquatint and fine, etched lines; as published in *l'Ymagier*

B. Collection Stéphane Malingue, Paris
Printed on thin, greenish wove paper
Purple SSSS stamp, upper right
From the collection of the painter and dealer, Georges Chaudet

C. Collection Eberhard Kornfeld, Bern
Printed on laid paper, watermarked "3"
Inscribed in pencil, lower center: tire a 3 epreuves
Gray AS and red EAS stamps, lower right

D. Collection Dr. & Mme. René Guyot, Clohars-Carnoët
Printed on buff laid paper

E. Collection Dr. & Mme. René Guyot, Clohars-Carnoët
Printed on same sheet of buff laid paper with an impression of no. 75
Yellow AS and blue SSSS stamps, lower right

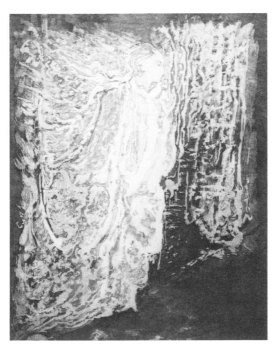

77A

77. The Spirit of a Woman 1894–95
l'Apparition
Open-bite aquatint
312 x 230

*A. Collection Pierre Fabius, Paris
Printed on fine, gray laid paper, watermarked MBM
Vente O'Conor 1956, no. 69

It is clear from this unique impression that Seguin employed several applications of acid over an aquatint ground in order to build up the image.

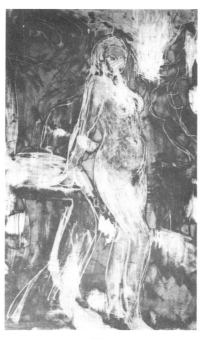

78A

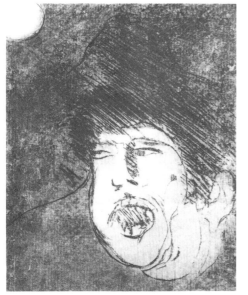

79A

78. Study of a Nude 1894–95
Monotype or open-bite aquatint
320 x 186

A. Collection Pierre Fabius, Paris
Printed on cream laid paper, with monogram watermark

In this unique impression it is reasonably certain that the design was drawn into the ink itself. Traces of a landscape (etching) are still visible.

79. The Idiot 1894–95
Etching and aquatint
131 x 101 (beveled plate)
Reference: Barc de Boutteville 1895, no. 30

A. Collection Pierre Fabius, Paris
Printed on cream laid paper, watermarked M (BM?)
Vente O'Conor 1956, no. 69

*B. Collection Eberhard Kornfeld, Bern
Printed on cream laid paper, watermarked ARCHES
Green AS stamp, lower right

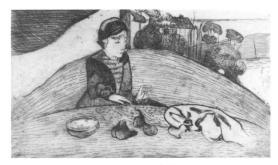

80 Art Institute of Chicago

80. The Woman with Figs 1894–95

La femme aux figues
Etching and lavis
268 x 444
Inscribed in plate, upper left: chez Seguin/à St. Julien
Published in *Germinal,* Paris, 1899 (edited by Julius
Meier-Graefe), no. 15
Edition 100
References: Guérin 88; Vente O'Conor 1956, no. 36; Chicago
1959, p. 76; Jaworska 1972, p. 141 and p. 245, note 108;
Quimper 1978, no. 81

A. Collection Eberhard Kornfeld, Bern
Proof(?) impression in greenish ink on laid paper showing
considerable plate tone
Signed in blue pencil, lower left: Seguin (artist's hand?)

B. 1899 impressions are to be found in many collections, including
the Fondation Jacques Doucet, Paris; Stéphane Malingue, Paris;
the Metropolitan Museum of Art, New York; the Museum of Fine
Arts, Boston; the Art Institute of Chicago, etc. After the edition
pulled for *Germinal* in 1899, the plate was occasionally proofed
by Delâtre. In the past decade or so, at least two other printings
(un-numbered) have taken place (the first of these is represented
by 'C').

C. Collection Bibliothèque Nationale, Paris (20)
Late impressions in blue-gray on medium, wove paper,
watermarked ARCHES

*D. Collection Davison Art Center, Wesleyan University
Late impression in greenish-gray on light, machine-made, laid
paper, watermarked INGRES

81. Saint John ca. 1895

After a drawing by Charles Filiger (1863–1928)
Etching and roulette
440 x 225
Reference: Barc de Botteville 1895, no. 62; exhibition *Charles
Filiger,* The Reid Gallery, London, October–November 1963,
no. 7 (Filiger's gouache reproduced in color)

*A. Collection Pierre Fabius, Paris
Printed on cream wove paper
Inscribed in blue pen, lower right: Filiger
Blue AS stamp lower right, and red AS stamp lower left, both
colored with gold paint; small etched flower at the lower left also
touched with gold and red
Purchased from M. Jean Cailac in 1959; from the sale of the
daughter of Marie Henry, Mme. Marie-Ida Cochennec, Hôtel
Drouot, 16 march 1959

There seem to have been at least three versions of this composi-
tion, all by Filiger. The one that was exhibited at the Tate Gallery
in 1966 (no. 140) and Le Bateau-Lavoir in Paris in 1962 (no. 11)
may be the largest. A second version was shown at the Reid
Gallery in London in 1963 (no. 7, reproduced in color), while a

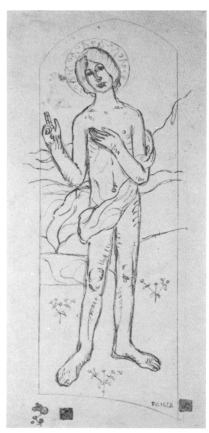

81A

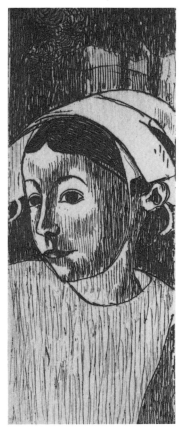

82B

third appeared in the O'Conor Sale of 1956 (no. 119). The latter was incribed "La lumière luit dans les Ténèbres." One of these may have been part of the decoration at Marie Henry's inn at Le Pouldu, ca. 1890. Although it is not mentioned in the account Marie Henry dictated to her long-time friend and later husband, Henri Mothèré (first published by Charles Chassé in 1921, pp. 26–52), Seguin himself refers to Filiger's *St. John* in his account of 1903 (*l'Occident*, vol. 3, no. 18, 1903, p. 305).

82. Breton Girl with Pinafore ca. 1895
Figure decorative(?)
Etching
163 x 62
References: Barc de Boutteville 1895, no. 65(?); London 1966, no. 179

A. Collection Museum of Modern Art, New York
Printed on thin, blue-green wove paper
Inscribed in pencil, lower right: 5/28
Collector's mark, lower right: KW in a circle
Green AS stamp, lower right

*B. Collection Samuel J. Wagstaff, Jr., New York
Printed on heavy, tan wove paper with much plate tone

C. Collection Eberhard Kornfeld, Bern
Printed in brown ink on medium weight, cream laid paper

Malingue Restrike Edition

83A

83. Breton Man 1894
Jeune garçon(?)
Zincograph
235 x 286 (image)
Dated in the stone, lower left: 1894
References: Barc de Boutteville 1895, no. 77(?); Chassé 1921, p. 21; London 1966, no. 183

A. Collection Paul Prouté, Paris
Printed on warm Japan paper
From the collection of André Mellerio (Sale, Hôtel Drouot, January 1938, no. 103)

*B. Collection Samuel J. Wagstaff, Jr., New York
Printed on a warm wove paper

This work is largely an experiment in tusche (drawing on the lithographic stone with wash and brush), an uncertain procedure that was not entirely successful in no. 85.

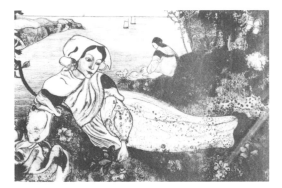

84D

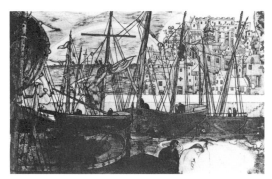

85A

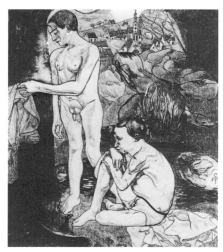

86A

84. Breton Woman Reclining by the Sea 1894–95

La primavera (Femme couchée)
Zincograph (image)
214 x 315
Signed in the stone, lower left: Seguin
Published in *l'Ymagier*, No. 2, January 1895
References: Barc de Boutteville 1895, no. 74; London 1966,
no. 182; Jaworska 1972, p. 140–41

A. Collection Pierre Fabius, Paris
Printed on green wove paper
Vente O'Conor 1956, no. 67

B. Collection Paul Prouté, Paris
Printed in brown ink on heavy wove paper
Green AS stamp, lower right
Possibly the impression from Mme. Ida-Marie Cochennec sold at
Hôtel Drouot, Paris, 16 March 1959, no. 34

C. Collection Eberhard Kornfeld, Bern
Printed in brown ink on grayish wove paper
Signed in pencil, lower right: AS

*D. Collection Samuel J. Wagstaff, Jr., New York
Printed in black on cream, imitation Japan paper
Inscribed in pencil, lower left: à l'ami Toul Lautrec/A. Seg.

E. Collection Eberhard Kornfeld, Bern
Printed in brown ink on cream, imitation Japan paper as were those
published for *l'Ymagier*
The original drawing exists in the Bibliothèque Nationale, Paris

85. Seaweed Gatherers and Bathing Women ca. 1895

Pêcheurs de goemons
Zincograph
202 x 287 (image)
Reference: Barc de Boutteville 1895, no. 75

A. Collection Bibliothèque Nationale, Paris (27)
Printed on smooth, ivory wove paper.
Inscribed in pencil, lower right: à Filiger/A. Seguin

*B. Collection Samuel J. Wagstaff, Jr., New York
Printed on smooth, off-white wove paper

Apparently the stone was desensitized during the proofing process
so that some extensive losses occurred at the lower right of the
image.

86. Two Bathers 1895

Zincograph
273 x 237 (image)
Signed in the plate, lower left margin: AS 1895; in the flower motif
and on the rock, lower right: AS
Reference: London 1966, no. 184

A. Collection Bibliothèque Nationale, Paris (19)
Printed on wove paper (imitation Japan)
Signed in crayon, lower left: A Seguin

B. Collection Samuel J. Wagstaff, Jr., New York(?)

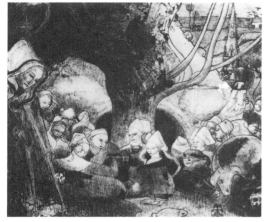

87A

87. The Toads† 1895
Les crapauds
Zincograph
214 x 257 (image)
Lithographed monogram in stone, lower right: two hands enclosing SS pattern with 1895 printed in a band
Inscribed in type, upper left: Tiré a 50 exemplaires
References: Jaworska, 1971, p. 140; Jullian, 1973, fig. 208

A. Collection Bibliothèque Nationale, Paris (18)
Printed on wove paper
Inscribed in crayon, lower right: à Filiger/A. Seguin (see nos. 66 & 82). Jaworska incorrectly thought the print was signed: à Filger/à Gauguin.

†A second title assigned by Jaworska, *Two Girls before the Chapel* makes no sense.

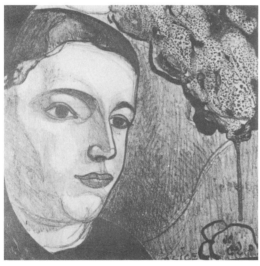

88B

88. Alice 1896
Zincograph
273 x 256 (irregular, drawn border)
Inscribed in the plate, lower right: ALICE
Signed in the plate, in reverse, lower right: 96/A. Seg
Reference: Mannheim 1963, no. 240

A. Collection Bibliothèque Nationale, Paris (24)
Printed in dark brown ink on tan wove paper

*B. Collection Pierre Fabius, Paris
Printed in dark brown ink on wove paper
Vente O'Conor 1956, no. 69

C. Collection Stéphane Malingue, Paris
Printed in dark brown ink on wove paper

D. Collection Kunsthalle, Bremen

89A

89. Fan: Breton Couple by the Sea ca. 1896
Color lithograph or zincograph with watercolor(?)
179 x 453 (entire image)
Signed in the stone on the margin inside the fan: AS with leaf
Reference: London 1966, no. 186

*A. Collection Samuel J. Wagstaff, Jr., New York
Outlines printed in red ochre, purple, and blue on cream wove paper, watermarked Ganson & Montgolfier; reworked in watercolor or monotype in orange, blue, green, and gold
Signed in blue crayon, lower right: No. 5 A. Seg

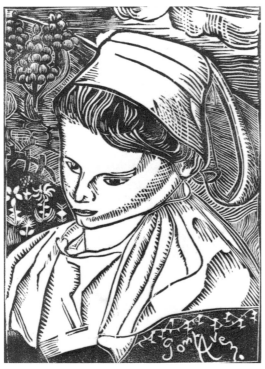

90c

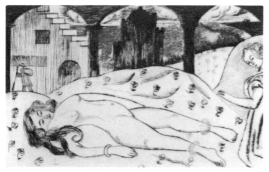

91A

90. Breton Woman from Pont–Aven 1896
Woodcut
162 x 113
Inscribed in white-line woodcutting, lower right: Pont–Aven
Reference: London 1966, no. 185 (2 examples)

A. Collection Bibliothèque Nationale, Paris (6)
Printed in dark brown ink on wove paper

B. Collection Pierre Fabius, Paris
Printed in black ink on thin Chinese paper
Signed in pencil, lower right: A. Seguin/96
Vente O'Conor 1956, no. 69

*C. Collection Samuel J. Wagstaff, Jr., New York
Printed in dark brown ink on Chinese paper

D. Collection Samuel J. Wagstaff, Jr., New York(?)
Printed in red, blue, and green

91. The Pilgrim of Silence 1896
Le Pélerin de Silence (Femme endormie devant une colonnade)
Drypoint and aquatint
100 x 178
Frontispiece for Remy de Gourmont's *Pelerine de Silence*,
published in Paris, 1896
Reference: Jullian 1973, fig. 209

A. Collection Bibliothèque Nationale, Paris (2)
Printed on heavy, cream laid paper

B. Collection Paul Prouté, Paris
Impression as frontispiece, printed in black ink on Hollande
van Gelder laid paper

Only the deluxe copies of the book contained the original
dryoint, often, according to Mme Prouté, tinted with pink wash.
In all, there were issued three copies on *Japon impériale*, six on
Chine, and twelve on *Hollande van Gelder*. The remaining copies
of the book were ornamented with a lithographed reproduction of
the drypoint, printed in blue, and measuring 100 x 150 mm.

92-1(I)

92. Illustrations for l'Image 1897

Periodical published in Paris, by Floury, in 1897
19 frames and vignettes designed by Seguin and executed as
wood-engravings by Tony Beltrand, Valéry, André, Germain,
J. Boudoin, Carbonneau, and Doreau

1. *Parati te Marae*, poem by Charles Morice inspired by the
 paintings and writings of Paul Gauguin; September 1897, No. 10,
 pp. 289–292 (9 images)

2. *Chanson d'Engaddi*, poem by Tristan Klingsor; September 1897,
 No. 10, p. 300 (1 image)

3. *Le Diable en Vacances*, by Jean Ajalbert; October 1897, No. 12,
 pp. 353–358 (7 images)

4. *Le Hamae*, by Coolus; October 1897, No. 12, p. 367 (2 images)

92-1(II)

92-1(III)

92-1(IV)

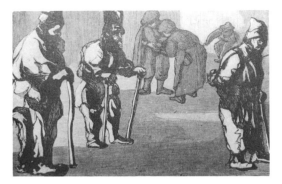

93 - 19

A

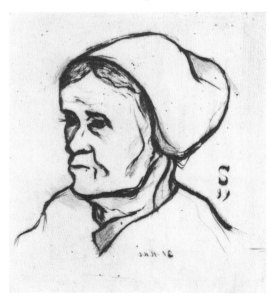

B

93. Illustrations for Aloysius Bertrand, *Gaspard de la Nuit,* **Paris, Ambroise Vollard, 1904**
213 wood-engravings after Seguin's drawings (1900–1903), engraved by Tony, Jacques, and Camille Beltrand
Issued in 350 copies, numbered:
 1–20 on Japan paper, with an extra set of artist's proofs
 without text, printed on Chinese paper;
 21–120 on Chinese paper;
120–350 on wove paper manufactured by Van Gelder.
In addition there were 24 extra sets of the wood-engravings printed on Chinese paper, lettered instead of numbered.
References: Ambroise Vollard 1948, pp. 314–315; Strachen 1969, p. 48; Johnson 1977, no. 205

A. The Trumpet Player 1896
Joueur de cornemuse(?)
Woodcut
70 x 110
Initials in wood upper left: J; and lower right: HD
A white-line '4' appears on the arm of the man at the left

Collection Bibliothèque Nationale, Paris (5)
Printed in gray-green on wove paper
Except for the fact that this woodcut (far more in the style of Charles Huard or Félix Vallotton than Seguin) came to the Bibliothèque Nationale with many of the other prints by Seguin, there is no evidence for including it in the present catalogue.

B. The Peasant 1899
La Paysanne
Drypoint
99 x 89
Signed with a monogram in the plate, lower right: S/99;
Inscribed in the plate, in reverse, lower center: 31 Mai

Stéphane Malingue, Paris
Printed on old, laid paper
Collector's mark lower right: KW in a circle (Jacques Ulmann, Paris?)

Except for the attribution of its owner, we know of no reason to include this work in Seguin's *œuvre.*

Appendixes A & B

*Checklist of Seguin Paintings and Drawings**

A. *Paintings*

1. **Head of a Girl** ca. 1891
 460 x 333
 Private Collection, Germany
 Barc de Boutteville no. 2
 London 1966, no. 166

2. **Woman Gathering Nuts**(?) 1892
 667 x 1473
 Ex-collection Silberman Galleries, N.Y.
 Paris 1893, no. 1195(?)
 Barc de Boutteville 1895, no. 1

3. **The Seine at Villeneuve–la Garenne**
 245 x 330
 Collection Musée de l'Association Paul Gauguin
 Pont-Aven 1967, no. 46

4. **Still Life** 1892–93 or 1896
 457 x 552
 Collection Arthur G. Altschul, N.Y.
 Paris 1893, no. 1196(?)
 Barc de Boutteville 1895, no. 5(?)

5. **Still Life with Fruits** 1892
 325 x 415
 Collection unknown
 Paris 1893, no. 1198(?)
 Barc de Boutteville 1895, no. 6(?)
 Pont-Aven 1967, no. 47

6. **The Delights of Life** 1892–93
 Four panels, each 1524 x 565
 Private Collection, U.S.A.
 London 1966, no. 319

7. **Breton Girl with a Rooster** 1893
 645 x 450
 Collection Pierre Fabius, Paris
 Paris 1893, no. 1199(?)

8. **Les Fleurs du Mal** ca. 1893
 521 x 343
 Collection Samuel Josefowitz, Lausanne
 Barc de Boutteville 1895, no. 7(?)

9. **Breton Peasants at Mass** ca. 1893
 546 x 381
 Collection National Museum of Wales, Cardiff
 London 1966, no. 163

10. **Three Breton Women** 1893–94(?)
 Collection Raymond Le Gloannec, Pont-Aven

11. **The Two Cottages** ca. 1894
 600 x 911
 Collection Samuel Josefowitz, Lausanne
 Barc de Boutteville 1895, no. 4(?)
 London 1966, no. 167

12. **The Village at Douélan**
 Collection unknown
 Barc de Boutteville 1895, no. 3(?)

13. **Portrait of Marie Jade (Mlle. Vien)** 1895(?)
 870 x 1140
 Musée National d'Art Moderne (Musée d'Orsay)
 London 1966, no. 165

14. **Nude in a Landscape** (so-called Portrait of
 Countess Zalposka) 1896
 960 x 1170
 Collection Dominique Denis, Saint Germaine-
 en-Laye
 London 1966, no. 318

15. **Seaport** ca. 1903(?)
 641 x 457
 Collection Mr. and Mrs. Bruce B. Payton,
 Minneapolis
 Minneapolis 1962

16. **Fisherman's Family** 1900–1903(?)
 298 x 394
 Collection Samuel Josefowitz, Lausanne
 London 1966, no. 168

17. **Harvest in Brittany** 1903
 930 x 720
 Collection Mlle. Henriette Boutaric, Paris
 Pont-Aven 1961, no. 153

B. *Drawings*

1. **Self-Portrait with Pipe** 1889
 Blue crayon, 320 x 210
 Collection Arthur G. Altschul, N.Y.

2. **Boats—A Fan** 1891 or 1897
 Gouache on parchment, 327 x 565
 Collection Mlle. Henriette Boutaric, Paris
 London 1966, no. 162

3. **Head of a Breton Girl** 1891
 Ink and crayon
 Collection Johann Langaard, Oslo

4. **Portrait of Eric Forbes-Robertson** 1891
 Pencil, 232 x 148
 Collection Miss Ida Forbes-Robertson, London

5. **Seated Woman with Feathered Hat** 1891–92
 Watercolor
 Collection Pierre Fabius, Paris

6. **At the Nouveau Cirque: The Spectators** ca. 1893
 Wash drawing, 350 x 220
 Collection Paul Prouté, Paris

7. **In the Cloister** ca. 1893
 Wash drawing, 262 x 322
 Collection Paul Prouté, Paris

8. **Breton Woman** 1893
 Pastel, 410 x 260
 Musée de Brest
 Quimper 1978, no. 76

9. **Pont-Aven Landscape** ca. 1894
 Pencil and charcoal, 260 x 350
 Collection Dr. Jean Paressant, Nantes

10. **Breton Laundress** ca. 1894
 Pencil, ink, charcoal, 212 x 308
 Collection Bibliothèque Nationale, Paris (7)

11. **Primavera** 1894–95
 Pencil and charcoal, 240 x 315
 Collection Bibliothèque Nationale, Paris (8)

12. **Portrait of Countess d'H.** ca. 1895
 Watercolor
 Collection unknown
 Chassé 1921, p. 65

13. **Profile of a Woman** 1895–96
 Pencil, red crayon, pale wash, 250 x 310
 Collection Bibliothèque Nationale, Paris (9)

14. **Breton Women Seated** 1901
 Watercolor, 131 x 362
 Collection Arthur G. Altschul, N.Y.
 London 1966, no. 170

A number of works have not been seen by the compilers of this list.

Appendix C

Gauguin's Preface to Seguin's 1895 Exhibition Catalogue

A gesture of deliberated sensitivity: this, I believe, is the ideal intention of a preface.

The need to be judged by others and to become informed about one's own efficacy: this, from the artist's point of view, is the only valid justification for an exhibition.

I am making this gesture: I am writing this preface because Seguin is, in my opinion, an artist. This word spares me the need to use superlatives because I employ it with deep acceptance of its near-sacred meaning, in the same way that Swedenbourg did when he said: "Somewhere in this world, there is a mysterious book in which the eternal laws of Beauty are written. From it, artists alone may unravel the true meaning, and indeed because the Lord had selected them to understand it, I shall call them the Elected."

And Swedenbourg was a learned man.

Seguin is not a master. His shortcomings are not yet sufficiently evident to merit this title. But he does know how to read in this mysterious *Book,* and he does indeed know how to speak the language of the *Book*. He has a personal conception of Beauty and the compulsion to seek it through his own personal means.

Today he is showing us the results of his efforts, so that for the sake of his own development, he may know the judgment of those he respects.

Indeed, there is no thought of fame on his part. This is why, on my part, there is no consideration of the obligations of friendship; there is only the genuine pleasure of speaking to art lovers who would hear me.

Here a talented artist has assembled the evidence of both his labors and his dreams.

To paint what one dreams about is an honest act.

It is to artists, his equals, that he speaks. By answering him with this gesture of my affection, I am in no way assuming any obligation to discuss esthetic theories, be they either of style or of technique. I am not an art critic.

It suffices for me to warn the visitor that Seguin is above all, cerebral. I certainly do not mean that he is a literary artist; he expresses not what he sees but what he thinks, by means of a unique harmony of lines, by a pattern curiously informed by the arabesque.

Nothing in him is academic; there is nothing of the conventional homage which expresses itself as sterile imitation.

He is by disposition, honest, robust, and healthy.

Seguin has freely studied nature. I met him in Brittany earlier this year.

I have already painted this beautiful land of Brittany. I have scanned the horizons, seeking the harmony of human life with both animal and vegetable lives in compositions where I have given an important role to the great voice of the land. Seguin, on the other hand, contents himself with figures in a restrained setting. In this way, he achieves very pleasing effects.

As you can see on this large horizonless canvas, a Breton peasant sleeps without affectation, without a dream; she is merely resting. Nothing literary; everything is said in the arabesque lines that describe this figure, and in the parallel and intersecting curves of interior and exterior contours. What cleverness there is in the dull tones of the bonnet which are summed up in a white!

I contend that this is a very beautiful color of black.

I would prefer, without question, that the subject matter be more distinguished. Less indifference and more skill, and surely the artist would excel in the subject.

By contrast, technique is pushed too far in the etchings; I would prefer more ingenuity. In that re-

spect, however, Seguin is unique in his individual understanding of drawing.

Those etchings which are perhaps most pleasing— the Parisian subjects—are not those which captivated me the longest. These days, Paris appears to be only a pretext for Parisian painters to make posters and caricatures, although sometimes I see *La Joconde* at the Folies Bergères. . . . But undoubtedly, I lack *Parisian feelings*.

———————

After being with him in Brittany, I was delighted to see Seguin again at Gallery Le Barc de Boutte-ville, among the "common people." (It is thus that learned academicians designate the non-official places where works of art are shown.)

The Soul breathes where it wishes, talent displays itself where it may. In my opinion, this preface serves Sequin only as an ornament; he can easily dispense with an introduction.

Finally, he shall have a place in the artistic history of our time (does he not already have one?), in the midst of the "common people." He will be remembered when all pretentious criticisms and childish remonstrances have long been forgotten.

Paul Gauguin

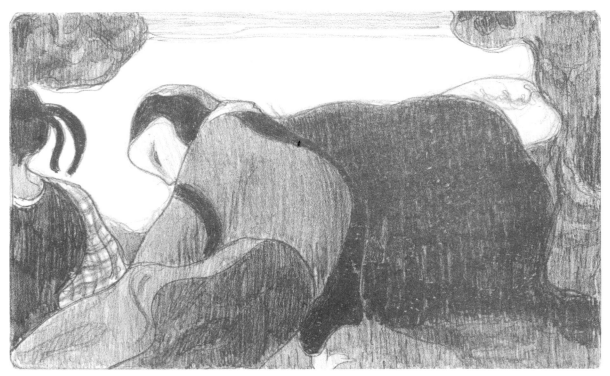

66A

Footnotes

1. The roles of Emile Bernard (1868–1941), Paul Sérusier (1864–1927), and Maurice Denis (1870–1943) in the development and dissemination of the styles and theories of Synthetism, Symbolism, and School of Pont-Aven, and the Nabis in Paris are discussed in many of the books cited in our bibliography, including those by Jaworska, Rewald, Chassé, Roskill, and Mauner.

2. Maurice Denis, "A propos de l'exposition Seguin," *La Plume*, vol. VII (March 1, 1895), pp. 118–19; reprinted in *Théories*, Paris, 1912, pp. 20–23.

3. See Appendix A for list of known paintings by Seguin.

4. This intention is strongly emphasized in Mauner 1978, pp. 157–58.

5. See Appendix C for our translation of Gauguin's *Preface* to the Seguin exhibition catalogue of 1895.

6. From a letter written by Seguin to Roderic O'Conor (1860–1940), December 1, 1898 (cited and translated in Jaworska 1972, pp. 142–43).

7. Mauner 1963 and Mauner 1978 offer several important insights about the symbolic content of interior scenes by Vuillard and the other Nabis.

8. Mauner 1978 and Humbert 1954, authors of the most carefully documented studies of the Nabis, find no evidence that Seguin was ever closely associated with the Nabis or that he ever exhibited with them.

9. See *Les Misérables* of 1888 (Wildenstein 239) and Gauguin's sketch in his letter to Emile Schuffenecker of October 8, 1888 (Malingue LXXI) and Merete Bodelsen's commentaries on them (in *Gauguin's Ceramics*, London, 1964, pp. 111–12, and Chapter VI, "Aspects of Gauguin's Style").

10. See, for example, Herbert et al. in New Haven 1965, p. 95, and Sutton in London 1966, no. 319. Jaworska 1972, pp. 144 and 146 does not venture a date.

11. The panels have no firm provenance; they came to this country ca. 1960 from a Parisian dealer who reported they had formed part of the decor of Marie Gloanec's Inn in Pont-Aven.

12. Reproduced in Jaworska 1972, p. 146 and London 1966, plate 32a. Another painting of this time, *Three Breton Women*, mentioned by Jaworska 1972, p. 145, has never been reproduced.

13. The drawing belongs to the Bibliothèque Nationale, Paris, while the painting hangs in the (future) Musée d'Orsay, Paris.

14. See Appendix B for list of known drawings.

15. Gabriela Zalposka, Polish actress, accompanied Sérusier to Brittany more than once, but for the last time in October 1894. Jaworska 1972, p. 245, note 111, denies that the model was Zalposka.

16. Chassé 1921, p. 65.

17. There is absolutely no word about Seguin's family in any of the literature. An "Arsène" Seguin exhibited for many years with the Société des Artistes Indépendants (born 1848 in St. Malo, Brittany), but we doubt there was any connection.

18. Malingue 1979, p. 33, without any source for his information.

19. On the Académie Julien see John Rewald, *Post-Impressionism, from Van Gogh to Gauguin*, New York, 1962, pp. 272 ff.

20. In a letter from Sérusier to Denis written from Pont-Aven in 1889, Sérusier says that "I have received news of the two Nabis, Seguin and Ibels. . . ." See Sérusier 1950, p. 40. As Mauner makes clear, this was a term of sympathetic interest and not necessarily an indication that Seguin was part of the Nabis group. See Mauner 1978, pp. 27–28.

21. See Maurice Denis, *Journals*, 1884–1904, I, Paris, 1957, p. 118 for the single reference to Seguin.

22. So far as we can determine, Seguin exhibited only two or three times during his short life. Once with the Salon des Indépendants in 1893, once at Le Barc de Boutteville in 1895, and then once during the summer of 1897 at Galerie Moline.

23. "Denis, Bonnard, Vuillard, Verkade, ils demeurent des artistes véritables, amoureux de recherches, savants de technique; nulle haine malgré le temps, n'est venue nous séparer, notre âme devant la Beauté s'émeut avec le même ardeur, notre poignée de mains est aussi fraternelle que jadis." Seguin in *l'Occident*, vol. 3, 1903, p. 163.

24. See Rewald 1962, pp. 278 ff.

25. Seguin in an unpublished letter(?), cited by Jaworska 1972, p. 139.

26. In Seguin's description of the group of artists working at Pont-Aven and Le Pouldu published in *l'Occident* in 1903 he nowhere implies that he knew Gauguin at any time prior to 1894. Gauguin, on the other hand, is quite specific; in the *Preface* he wrote for Seguin's 1895 exhibition, he clearly states that he had met Seguin earlier that year (meaning 1894). Emile Bernard, in his own reminiscences states that he worked with Seguin in the winter of 1892–93; see *Souvenirs inédits*, Paris, 1939, p. 19. Bernard also wrote Charles Chassé, "Seguin, whom Gauguin later snatched from me, met me in 1892 at Pont-Aven"; see Chassé 1969, p. 72.

27. Reproduced in Sutton 1974, p. 404.

28. E.g., H. Fuchs in Mannheim 1963, n.p.; Paris 1949, p. 104.

29. See Jean Harris, *Edouard Manet: Graphic Works*, New York, 1970, no. 53 (the fifth state might have been reworked by Félix Bracquemond). The Gauguin and Bernard paintings are reproduced in Rewald 1962, p. 466 and p. 206.

30. We have not seen the pointillist fan *Boats*, exhibited in London 1966, no. 162. We are not sure that its style could be grounds for an early dating, since there was a wave of

interest in pointillism again in the mid– to late–1890s. See for example Denis' fan of 1897, *Le Port du Pouldu*. Seguin's fan just might have been one of those he executed for quick sale in 1897 (see note 110).

31. See Verkade 1923, pp. 101 ff; and Chassé 1947, p. 141.

32. Compare Gauguin's *La Ronde des petites Bretonnes* (Wildenstein 251) and Sérusier's *Quatre Bretonnes*, 1891 (Mauner 1978, fig. 94).

33. Sutton 1974, p. 406. Coincidentally, Lucien Pissarro's contribution to *l'Estampe originale* in 1894 was a wood-cut *Ronde d'enfants* (see Stein 1970, no. 54). Although pronouncedly English in style, it suggests another early source for Seguin's work, a source which strongly reappears in the illustrations of 1900–1903 for *Gaspard de la Nuit*.

34. Sutton 1974, p. 405.

35. Henri Delavallée (1862–1943), painter and printmaker, is almost unknown in this country (I could not find one of his prints in the Northeast). His prints may be seen in some quantity in the Cabinet des Estampes at the Bibliothèque Nationale, Paris. He has had but one recent exhibition (1974 in Pont-Aven) and has been afforded some attention by Sutter 1970, pp. 171–74; Tuarze 1973; and Quimper 1958.

36. Sutton 1974, p. 405.

37. *Lavis* usually indicates the simple application of acid to an ungrounded plate with a brush (sometimes called "spit-bite"). *Open-bite* is a term often used to denote the same process, but we prefer to use it in conjunction with an aquatint ground. The result is an aquatint tone that has all the irregularities and transparencies of *lavis*.

38. Cabinet des Estampes, Bibliothèque Nationale, call number Ef. 507 FOL.

39. Denis executed the drawings for *Sagesse* in 1889–1890, but they were not issued as illustrations until 1910 when they were published by Ambroise Vollard. But quite a number of the drawings were shown in Paris during the early 1890s, for example, in the Salon des Artistes Indépendants of 1891.

40. Essentially the composition of *Woman with a Feathered Hat* is quite similar to Whistlerian formulations (e.g. *Symphony in White No. 2*, 1864) which were responsible for many late 19th century images, including Joseph Rippl-Ronai's *Woman with a Vase* of 1892 in the Altschul Collection. Ronai was called the "Hungarian Nabis."

41. For an excellent discussion of the rise and significance of color lithography in 1885–1900, see the catalogue of the exhibition, *The Color Revolution*, Rutgers University Art Gallery, New Brunswick, New Jersey, 1978.

42. There is perhaps some relationship to Gauguin's decorative wave forms as drawn in his zincographs of 1889, e.g., *La Baigneuse* (Guérin 3).

43. See Rodolphe Bresdin's *La Maison Hantée* and other etchings in Dirk Van Gelder, *Rodolphe Bresdin*, 2 vols., The Hague, 1976.

44. It is very tempting to place these two landscapes with the series of 1893, but we feel that they are different enough in both style and technique to give them to 1892. Malingue told me that he regarded *The Majestic Trees* as the work of O'Conor. Although strongly related to O'Conor's etchings there is a looseness and fluidity of tone that is foreign to O'Conor's style and technique.

45. Jean Baptiste Camille Corot (1796–1875) and Charles François Daubigny (1817–1878) were two of the most inventive etchers of the Barbizon school. Their non-academic approach to landscape composition is echoed in the looseness of their handling of the etched line. Although Seguin makes no direct reference to any of their works (as he did to one of Jean François Millet in catalogue no. 71), in the 1890s they must have represented a venerable tradition of French landscape printmaking. Compare for example, Corot's *Ville d'Avray* and *Souvenirs des fortifications de Douai* (Delteil 3 & 12) or Daubigny's late etchings, e.g. *Lever de lune sur les bords de l'Oise* and *Pommiers à Auvers* (Delteil 123 & 126).

46. What little is known of O'Conor is set forth in Denys Sutton, "Roderic O'Conor," *The Studio*, vol. 160, no. 811 (November 1960), pp. 168–74, 194–96, and in Jaworska 1972, pp. 219–26. The sale of O'Conor's collection took place at Hôtel Drouot, Paris, February 6 & 7, 1956.

47. We have actually seen twelve landscape etchings by O'Conor (four are owned by the Museum of Fine Arts, Boston); in addition, Sutton 1960, pp. 173–74 mentions two more, a portrait and a peasant study. Jaworska 1972, p. 224 reproduces one lithograph. None of the landscapes is dated earlier than 1893.

48. The paintings listed in the catalogues of the Salon des Artistes Indépendants (1893) and of Seguin's exhibition at Le Barc de Boutteville's gallery seem to tally with known works. Only one of the works that Jaworska cites from the unpublished letters cannot be identified.

49. Not only did Denis execute drawings that would appear in Vollard's edition of *Sagesse* in 1910 as wood-engravings, but a number of designs had already been translated into print media by the early 1890s. See, for example, the lithograph, No. 16, in Pierre Cailler, *Catalogue raisonné de l'œuvre gravé et lithographié de Maurice Denis*, Geneva, 1967. Several wood-engravings and lithographs appeared in the periodical, *l'Epreuve*, in 1895.

50. Vuillard's first four-panel screen dated from 1892 (see Mauner 1978, p. 301, note 3), and Bonnard's, probably from 1891 (see John Rewald, *Pierre Bonnard*, New York, 1948, pp. 64–65).

51. The handsome theater program cover design was recently sold at Sotheby-Parke Bernet, New York, December 6, 1979, no. 72A (reproduced in color).

52. See Claude Roger-Marx, *l'Oeuvre gravé de Vuillard*, Monaco, 1948, nos. 7, 16–23; and idem, *Bonnard Lithographe*, Monaco, 1952, nos. 1, 5–24 (*Petites Scènes Familières*, 1893).

53. See catalogue no. 69 of Seguin's exhibition catalogue of 1895 for the fourth (lost) Valmondois subject.

54. Seguin did know and admire Pissarro's etchings. *Paysage*

à Osny (1887, Delteil 70) is remarkably close to Seguin's 1893 landscapes; but whereas Pissarro aimed to retain considerable atmospheric feeling in his prints, Seguin—in many of his landscapes—worked towards greater clarity and graphic expressiveness.

55. See Löys Delteil, *Le Peintre-Graveur illustré*, vols. 10 & 11, Paris, 1920, nos. 179–89, especially no. 182.

56. These etchings were not mentioned by Bernard or Natanson in their very brief reviews of Seguin's entries in the Salon des Artistes Indépendants of 1893, but their omission does not have any necessary effect on our chronology.

57. See for example, Lautrec's *Divan Japonais* and *Reine de Joie* of 1892 and his *La Revue Blanche* and *May Milton* of 1895 (Delteil 341, 342, 355 & 356).

58. Camille Mauclair, "Chose d'art," *Mercure de France*, vol. 13, no. 63 (March 1895), p. 358.

59. The same treatment of shape and deformation of the human figure appear in two drawings of 1893 in the collection of Paul Prouté, *Au Nouveau Cirque: Les Spectateurs* and *Dans l'église.*

60. Although there are occasional rapprochements with the work of Seguin's fellow printmakers, H.-G. Ibels (1867–1936) and Charles Maurin (1856–1914), there is very little in their work that would account for the extreme distortions of Seguin's Parisian café etchings and drawings. Maurin's 1893 *Portrait of Toulouse-Lautrec* (Stein 1970, no. 46) suggests some technical but hardly any stylistic connections.

61. Cuno Amiet (1868–1961) visited Brittany from May 1892 through June 1893. Although he worked with Seguin and made two or three etchings in Le Pouldu, Amiet barely mentions him in his short recollections published in 1922 (Cuno Amiet, "Erinnerungen an die Bretagne," *Das Werk*, vol. 9, no. 1 (1922), p. 8: "Ich fand O'Conor, den klugen, kraftvollen Irländer, in hellen, ungebrochenen Farben malend; Armand Seguin, liebeswürdig, geistreich, alles versuchend; Emile Bernard, der schon alles hinter sich gebracht hatte. . . ."). For Amiet's Breton etchings see Conrad de Mandach, *Cuno Amiet, Vollständiges Verzeichnis der Druckgraphik des Künstlers*, Bern, 1939, nos. 1–3.

62. Although a conservative painter, Maxime Maufra (1861–1918) defended Gauguin's paintings in 1893 and became a rather good friend of the Pont-Aven group. Jaworska 1972, pp. 191–98, takes pains to note that Maufra's simplified and quite gestural drawings and lithographs are not simply Impressionist studies, but relate to those of Seguin and Sérusier (I would add O'Conor).

63. Sutton 1960, p. 174, claims that it was probably Seguin who taught O'Conor how to etch; and it is true that our chronology dates Seguin's first web-like landscapes to 1892, the year before O'Conor may have commenced his. Nevertheless, we cannot but suppose that O'Conor had a profound influence on Seguin's art. If one compares their landscape etchings, O'Conor's emerge as more energetic and even more abstract. But they are less spatial, less sensitive to texture and rhythmic variety than Seguin's, and certainly less experimental. Peculiarly, most of O'Conor's wild bursts of foliage are surrounded by a containing contour.

64. J. B. de la Faille, *l'Oeuvre de Vincent van Gogh*, Paris, 1928, no. 720.

65. Henry Moret (1856–1913) was the most steadfast Impressionist of all the Pont-Aven painters associated with the Gauguin circle; see Jaworska 1972, pp. 181–86.

66. The lithograph executed in 1893 for *l'Estampe originale*, titled *The Road from Gaud* (Stein 1970, no. 45), is quite close in feeling to O'Conor's lone lithograph and even to Seguin's two lithographs of 1893, *The Plain* and *The Daydream*. Maufra's etchings are more traditional, but some, like the *Boats at Anchor* of 1893, might have been done with Seguin and O'Conor in Le Pouldu.

67. Denis' famous statement, "It is well to remember that a picture—before being a battle horse, a nude woman, or some anecdote—is essentially a plane surface covered with colors assembled in a certain order." Remember that Denis is not espousing abstraction, but only insisting that the formal aspects of painting be recognized as a prime expressive vehicle. The statement first appeared in *Art et Critique*, 23 August 1890, under the pseudonym Pierre Louÿs (he refers to it in his review of Seguin's exhibition, quoted in the above essay). Our English translation is taken from Herschel B. Chipp, *Theories of Modern Art*, Berkeley, 1968, p. 94.

68. Seguin in *l'Occident*, vol. 3, no. 16 (1903), p. 166.

69. See note 26. Bernard departed for Cairo in March of 1893 and did not return to France for good until 1902.

70. Prints dedicated to Filiger are catalogued under numbers 68, 84, and 87; no. 81 is copied after a Filiger drawing. See Jaworska 1972, pp. 159–68 for a brief biography of Charles Filiger (1863–1928).

71. The pastel is reproduced in the exhibition catalogue, Quimper 1978, no. 76.

72. The *Buckwheat Harvest* is reproduced in Jaworska 1972, p. 37; the tapestry of 1892 in Rewald 1962, p. 301.

73. There is no catalogue of Bernard's prints; the most extensive list appeared in Bremen 1967, nos. 193 ff. *Les Bretonneries* of 1889 are described under numbers 198–204, but we have found several other colored zincographs that might have been executed at the same time. These works seem far closer to Seguin's studies than the series of zincographs Bernard executed in 1892 to accompany the publication of Jean Moréas, *Les Cantilènes* (Bremen 1967, nos. 205–11).

74. Bremen 1967, no. 202.

75. The wording of Seguin's 1895 exhibition catalogue appears to imply that both *The Plain* and *The Daydream* were lent by *l'Estampe originale*; were these lithographs rejected commissions?

76. Hofstätter 1965, p. 77. This notion is entirely false. Munch had developed both his landscape idiom and his symbolic content long before 1893. See, for example, the painting *Melancholy, Yellow Boat* 1891/92 in the National Gallery, Oslo.

77. We are referring to the lithograph on page 86 of André Gide, *Le Voyage d'Urien*, Paris, Librairie de l'Art Indépendant, 1893. See Cailler 1968, no. 62.

78. See Erwin Panofsky's famous essay "Et in Arcadia Ego: Poussin and the Elegiac Tradition," in *Meaning in the Visual Arts*, Garden City, New York, 1955, pp. 295–320.

79. I am indebted to my student, Katharine Hannaford, Wesleyan Class of 1979, whose paper on *The Motif of the Fruit Gatherer in Late Nineteenth Century French Painting and Prints* provided much of the substance of what I have written. Hofstätter 1965, p. 21 mentions the motif and associates it with the theme of fertility.

80. Wayne Andersen, *Gauguin's Paradise Lost*, New York, 1971, especially pp. 84–111.

81. Sérusier was not particularly active or interested in printmaking, although he did make a few lithographs. For the most part these appeared as contributions to various publications (catalogues of *Exposition de la Depêche de Toulouse* and of *Le Barc de Boutteville*; *Album de la Revue Blanche*; *l'Estampe originale*; *l'Epreuve*—two images; and program covers for *Théâtre Libre* and *Théâtre de l'Oeuvre*).

82. See note 26. For the fracas at Concarneau on the 25th of May 1894, see René Maurice, "Autour de Gauguin. Sa rixe à Concarneau," *Nouvelle Révue de Bretagne*, November–December 1953.

83. Wildenstein 372, incorrectly assigned to 1889. For the correct date see Zurich 1966, no. 37.

84. See E. W. Kornfeld and P. A. Wick, *Paul Signac. Catalogue raisonné de l'Oeuvre gravé et lithographié*, Bern, 1974, nos. 6 & 17; and Stein 1970, no. 82.

85. See Field 1973, passim; and idem, "Gauguin's Noa Noa Suite," *Burlington Magazine*, vol. 110, no. 986 (September 1968), pp. 500–11.

86. See Delavallée's etching and aquatints, *Bretonne en noir* and *Le Hameau Kerviguelen*, both dated 1893.

87. Lift-ground aquatint is a positive method of drawing with the brush on the copper plate; the drawing or brushstrokes emerge as areas of aquatint that preserve the feeling of the hand of the artist. The method was rarely used in the 19th century, although it was undoubtedly known in the 17th!

88. See note 85. Gauguin's woodcut, *Auti te Pape* (Guérin 35) seems particularly close to Seguin's designs. Another comparison with Seguin's *A Summer Day* (no. 72) might be Paul Ranson's *Femme dans un jardin*, a painting of the middle 1890s, reproduced in Mannheim 1963, no. 173.

89. See for example *Composition II*, 1910; see Will Grohmann, *Wassily Kandinsky, Life and Work*, New York, 1958, classified catalogue no. 35.

90. On the 22nd of November 1894 Charles Morice gave a dinner in Gauguin's honor; see his account in *Le Soir* (Brussels), November 23, 1894. Early in December Gauguin held a small, private exhibition of his works in woodcut and watercolor monotype; see Morice's account in *Le Soir*, December 4, 1894; also Field 1973, pp. 16–17.

92. Seguin purchased two oils from the sale: #4 *Matamoe* (Wildenstein 484) and #28 *Noa Noa* (Wildenstein 487), according to Jean de Rotonchamp, *Paul Gauguin*, Paris, 1925, pp. 154–55.

93. One is reminded of certain drawings by Gauguin; for example, the pastel reproduced on p. 63 of Charles Morice, *Paul Gauguin*, Paris, 1920, p. 63; the *Head of a Tahitian*, no. 92, in John Rewald, *Gauguin Drawings*, New York, 1958; *Head of A Tahitian*, monotype of 1894, reproduced in Field 1973, no. 23. The pose of Seguin's two aquatints (nos. 75 & 76) also relates to Gauguin monotypes, (see Field 1973, nos. 21 & 22). Furthermore, the motif of Seguin's woodcut of the fall of 1894, *Three Breton Women with Infants* (no. 70) may have been derived from another Gauguin monotype (see Field 1973, no. 29).

94. We do not understand why Harold Joachim assigned a date of ca. 1886 in the catalogue for the exhibition *Gauguin*, Art Institute of Chicago and Metropolitan Museum of Art, New York, 1959, p. 76 and no. 126. Guérin 1927, no. 88 gives no date for the execution of the plate; he says simply, "Elle portait le nom de Gauguin, mais elle est en réalité l'œuvre d'Armand Seguin." Jean Cailac reported to Sam Wagstaff in 1960 that Guérin had seen a proof of *La femme aux figues* signed by Seguin, and for that reason he had not included it in the canon of Gauguin's work.

95. See Mark Roskill, "An Unexpected Gauguin Discovery," *Bulletin of the Museum of Fine Arts, Boston*, vol. 62, no. 328 (1964), pp. 81–88. The painting was begun while Gauguin was in bed during the summer of 1894.

96. Also reproduced in color in Jaworska 1972, p. 225.

97. For the dating of this woodcut see Field 1968, p. 510. Fall 1894 is conjectural, but the use of monotype to color the five versions of this print strengthens our contention.

98. It is tempting to separate two levels of work in the plate for *La femme aux figues*: the softer, open-bite and aquatint as being Gauguin's sketch, and the etched work as being Seguin's. Attractive as this idea might be, we have not been able to detect sufficient underdrawing with the brush to lend weight to such an hypothesis.

99. In the sale of O'Conor's collection at the Hôtel Drôuot February 6 & 7, 1956, no. 36, *La femme aux figues* is described as follows: "Cette eau-forte a été dessinée par Gauguin chez Seguin à Saint-Julien, en 1895, en présence de O'Conor, sur un zinc vernis et mordu par Seguin. Ce zinc, en 1899, est tiré par Eugène Delâtre pour l'album 'Germinal'." Finally there is a letter from Eugène Delâtre to Jean Cailac, dated 6 April 1938, published in edited form by the firm of Blache of Versailles, catalogue of their sale of 1 April 1962, no. 6:
Cher Monsieur:
En ce qui concerne la planche de Gauguin, voilà comment cela s'est passé: M. Seguin était en Bretagne entouré de ces artistes, Gauguin, O'Conor, etc., ils se sont amusés à graver des eaux-fortes sur les mauvais zincs; seul M. Seguin savait faire mordre et vernis une planche, il a donc vernis et fait mordu celle de M. Gauguin, mais en presence de M. Gauguin qui avait gravé lui-même et dessiné sur le metal.

67A

Cette planche est restée à mon atelier, n'ayant jamais reçu l'ordre de la biffer, elle nous servait de fausse marge pour faire des petits tirages et est aujourd'hui trés usée. Voilà cher Monsieur tout ce que je sais sur cette histoire.

100. The July number of *l'Ymagier* also advertised a suite of six lithographs by Louis Roy; a *Landscape* appeared in the issue of April 1895, and another lithograph entitled *A l'Eglise* appeared in July 1895 (with an O'Conor etching); perhaps a third image by Roy was the zincograph owned in two versions by the Rutgers University Art Gallery, *Nude in a Landscape* (not very far removed from Seguin's *Primavera* [no. 85]).

101. This print has been published by Field 1968, p. 504, note 10, and reproduced in idem, *Paul Gauguin: The Paintings of the First Voyage to Tahiti*, New York, 1977, figure 49. An interesting excerpt from a letter from Seguin to O'Conor may bear on this image: "Reprenant mes affaires chez Ibels, je trouve les Dürer que vous aimiez et vous les adresse, ainsi qu'une lithographie mauvaise de tirage, par Gauguin, tirée par Roy." The citation describes the *Parao Hano Hano* zincograph sold at the Vente O'Conor no. 28; the letter is dated 30 July 1897.

102. For example, Gauguin's *Ramasseuses de Varech* of 1889 (Wildenstein 349).

103. Camille Pissarro, *Letters to his Son Lucien*, edited by John Rewald and Lucien Pissarro, New York, 1943, p. 262; letter of February 28, 1895.

104. Ambroise Vollard, *Souvenirs d'un marchand de tableaux*, Paris, 1948, p. 315.

105. We must admit that the technique used for the fan, *Breton Couple by the Sea* (no. 89), is far from understood. The one surviving example seems to be an imitation of Gauguin's watercolor monotypes of 1894. Still, the heavy contour lines, though of varying color, do seem to be printed, as do some of the other colors.

106. For almost two decades we have tried to persuade Mr. Denys Sutton of London to allow us access to these letters; we can only hope they find a publisher before long.

107. Seguin's *Breton Girl with Pinafore* (no. 82) possesses something of the stark verticality of form and structure that recalls Filiger's work; see his undated *Breton Fisherman's Family*, illustrated in Jaworska 1972, p. 160.

108. See Marie Jade's account in *Le Figaro Littéraire*, 23 August 1952.

109. A closely related watercolor is reproduced in Chassé 1921, p. 65.

110. The exhibition took place at the Galerie Moline, 20–25 July 1897; see Jaworska 1971, p. 158, note 29, and Jaworska 1972, p. 141. Unless the fan entitled *Boats* (London 1966, no. 162—given to ca. 1890) was one of those exhibited, nothing from this exhibition survives.

111. A number of letters from Seguin to Maurice Denis are preserved in the collection of Dominique Denis, St. Germain-en-Laye, and were most kindly made available to Cynthia Strauss by Mme. Denis and Mme. Marie Amélie Anquetil, Curator.

112. Jaworska 1972, p. 245, note 110.

113. These letters are quoted in Jaworska 1972, p. 147 and pp. 142–43, respectively.

114. Unfortunately Jaworska has twice made the same error, claiming that it was 1889 when Seguin apprenticed himself to Feuerstein (Jaworska 1971, p. 149; and Jaworska 1972, pp. 142–43). Furthermore, the journal *Le Rire* only started up in 1894! We have searched every issue of *Le Rire* and have found not one work signed by or given to Seguin.

115. Letter from Seguin to O'Conor of 14 November 1900, cited by Jaworska 1971, p. 150.

116. On the 12th of July Sérusier wrote to Denis: "For the past week I haven't been alone here. Seguin has left Châteaulin and is staying with me. His presence not only gives me pleasant company but spurs me to work. While he is doing his drawings for *Manfred* I would be ashamed not to work, and I do work." Published in Sérusier 1950, p. 101, and translated in Jaworska 1972, p. 245, footnote 116.

117. A considerable number of Seguin's letters from this period have been preserved, namely those written to O'Conor, Sérusier, and Denis. Several are quoted in Jaworska's chapter on Seguin.

118. We cannot be at all sure that *Seaport* dates from this very last period; it has been exhibited only once.

119. 10 July 1902; Collection Dominique Denis, Saint Germain-en-Laye. We are indebted to Mme. Denis and Mme. Anquetil for making this letter available.

120. I am indebted to a paper submitted by one of my seminar students, Elizabeth Dunn, Wesleyan Class of 1979, for much of my analysis, however brief, of *Gaspard de la Nuit*. It is fascinating to reflect how Gaspard's book of magic spells and secret insights about the arts recalls the *Book* of Swedenborg about which Gauguin speaks in his *Preface* to Seguin's exhibition catalogue!

121. Some of the artists or styles represented: 16th century woodcut styles: pp. 11, 153, 173, frontispiece; Dürer: pp. xxiii, 23, 191, 297, 299; Callot: pp. 207, 208, 271(?); Rembrandt, 19, 47, 51, 247, 255; 17th century Netherlandish schools: pp. 3, 7; Fuseli-Blake: pp. 35, 91, 99(?); Goya: p. 39; late 19th century: 1, 267.

122. E.g., pp. 11.

123. E.g., p. 1.

124. E.g., p. 19. Although the publication date of the Vollard edition of Gaspard is 1904, it would seem from Seguin's comments that the book might have been released in 1903. On the 27th of November Seguin wrote to O'Conor: "It's charming, and it may go on for a long time yet [i.e. success as illustrator]; then one fine day I shall be dropped and find myself more alone and poorer than ever, after wasting valuable years in ruining my powers and turning out shit; in a year from now, if they haven't done it already, they'll be sticking a ticket on me: 'illustrator—illustrator at cut prices'." (Jaworska 1972, p. 142).

Bibliography

Alexandre, Arsène. *Maxime Maufra*, Paris, 1926.

Amiet, Cuno. "Erinnerungen an die Bretagne," *Das Werk*, vol. 9, no. 1 (1922) pp. 7–9.

Andersen, Wayne, and Klein, Barbara. *Gauguin's Paradise Lost*, New York, 1971.

Auriant. "XII lettres inédites de Charles Filiger," *Maintenant*, no. 6 (July 1947), pp. 237–46.

Bairati, Eleanora. "The Graphic Art of the Nabis," *Print Collector*, no. 5 (November–December 1973), pp. 9–27.

Bernard, Emile. "Sur l'Exposition des Indépendants," *l'Art littéraire*, vol. 2, no. 6 (May 1893), p. 24.

——————— . *Souvenirs inédits*, Paris, 1939.

Cailler 1968 Cailler, Pierre. *Catalogue raisonné de l'œuvre gravé et lithographié de Maurice Denis*, Geneva, 1968.

Chassé 1921 Chassé, Charles. *Gauguin et le groupe de Pont-Aven*, Paris, 1921.

Chassé 1947 ——————— . *Le Mouvement symboliste dans l'art du XIXe siècle*, Paris, 1947.

Chassé 1969 ——————— . *The Nabis and their Period*, New York, 1969.

Dauberville, Jean and Henry. *Bonnard, Catalogue raisonné de l'œuvre peint*, 4 vols., Paris, 1974.

Dauchot, F. "Meyer de Haan en Bretagne," *Gazette des Beaux-Arts*, 6e Pd, vol. 40, no. 12 (December 1952), pp. 355–58.

Dautier, Yves. *A propos de quelques collections bretonnes. Sérusier et les peintres du Groupe de Pont-Aven*, Rennes, n.d. (diploma thesis on deposit).

Delevoy, Robert L. *Symbolists and Symbolism*, New York, 1978.

Delteil Delteil, Löys. *Le Peintre-Graveur Illustré*, 31 vols., Paris, 1906–1926.

Denis, Maurice. "A propos de l'exposition Seguin," *La Plume*, vol. 7 (March 1, 1895), pp. 118–19; reprinted in *Théories*, Paris, 1912, pp. 20–23.

——————— . Obituary A. Seguin, *l'Occident*, vol. 5 (February 27, 1904), pp. 99–100; reprinted in *Théories*, pp. 23–24.

——————— . *Théories 1890–1910. Du Symbolisme et de Gauguin vers un nouvel ordre classique*, Paris, 1912.

——————— . *Journal, Vol. I, 1884–1904*, Paris, 1957.

Field 1968 Field, Richard S. "Gauguin's Noa Noa Suite," *Burlington Magazine*, vol. 110, no. 986 (September 1968), pp. 500–11.

Field 1973 ——————— . *Paul Gauguin: Monotypes*, exhibition catalogue, Philadelphia Museum of Art, 1973.

Gauguin, Paul. *Preface*, in the catalogue for the exhibition Armand Seguin, Paris, Galerie Le Barc de Boutteville, February–March 1895, pp. 5–14; reprinted in *Mercure de France*, vol. 13, no. 63 (March 1895), pp. 222–24.

Goldwater, Robert. *Symbolism*, New York, 1979.

Guérin Guérin, Marcel. *l'Oeuvre gravé de Gauguin*, 2 vols., Paris, 1927.

Guicheteau, Marcel. *Paul Sérusier*, Paris, 1976.

Guy, Cecile. "Le Barc de Boutteville," *l'Oeil*, no. 124 (April 1965), pp. 31–36, 58–59.

Hermann, Fritz. *Die Revue blanche und die Nabis*, 2 vols., Munich, 1959.

Hofer, Philip. *The Artist and the Book, 1860–1960, in Western Europe and the U.S.*, Boston, 1961.

Hofstätter, Hans. "Emile Bernard—Schüler oder Lehrer Gauguins?" *Das Kunstwerk*, vol. 11, no. 1 (July 1956), pp. 3–10.

Hofstätter 1965 —————————— . *Symbolismus und die Kunst der Jahrhundertwende*, Cologne, 1965.

Hofstätter 1968 —————————— . *Jugenstil Druckkunst*, Baden-Baden, 1968.

—————————— . *Idealismus und Symbolismus*, Vienna, 1972.

Humbert, Agnes. *Les Nabis et leur epoque*, Geneva, 1954.

Jade, Marie. "Gauguin que j'ai connu," *Le Figaro littéraire*, vol. 7, no. 331 (23 August 1952), p. 9.

Jaworska, Wladyslawa. "The Problems of Pont-Aven," *Apollo*, vol. 83, no. 51 (May 1966), pp. 372–77.

—————————— . "Jacob Meyer de Haan," *Nederlands Kunsthistorisch Jaarboek*, vol. 18 (1967), pp. 197–226.

Jaworska 1971 —————————— . "Armand Seguin: Peintre ou Graveur 1869–1903," *Gazette des Beaux-Arts*, 6e Pd., vol. 77, no. 1225 (February 1971), pp. 145–58.

Jaworska 1972 —————————— . *Gauguin and the Pont-Aven School*, London and New York 1972.

Johnson 1977 Johnson, Una. *Ambroise Vollard, Editeur; Prints, Books, Bronzes*, New York, 1977.

Julian 1973 Julian, Philippe. *The Symbolists*, London, 1973.

Kornfeld, E. W., and Wick, P. A. *l'Oeuvre gravé et lithographié de Paul Signac*, Bern, 1974.

Kornfeld, E. W. *Estampes des peintres de la "Revue Blanche," Toulouse-Lautrec et les Nabis*, Catalogue 50, Bern, 1950.

Le Bihan, O. "Chamaillard et le groupe de Pont-Aven," *Bulletin des Amis du Musée de Rennes*, vol. 2 (1978), pp. 120–29.

Lucie-Smith, Edward. *Symbolist Art*, New York, 1972.

Luthi, J. J. *Emile Bernard l'initiateur*, Geneva, 1974.

Malingue Malingue, Maurice, ed. *Lettres de Gauguin à sa femme et à ses amis*, Paris, 1946.

—————————— . "Petits et Grands Nabis," *l'Oeil*, no. 62 (February 1960), pp. 36–45.

Malingue 1979 —————————— . "La vie brève et douloureuse d'Armand Seguin, créature original," *Journal de l'amateur d'art*, no. 638 (January 15, 1979), p. 33.

Mashack, Joseph. *"Gauguin and the Pont-Aven School"* review, *Art in America*, vol. 61, no. 6 (November 1973), pp. 138–39.

Mauclair, Camille. "Chose d'art, Chez Le Barc de Boutteville," *Mercure de France*, vol. 12, no. 60 (December 1894), pp. 384–86.

—————————— . "Chose d'art," *Mercure de France*, vol. 13, no. 63 (March 1895). pp. 358–59.

Maufra, Maxime. "Gauguin et l'Ecole de Pont-Aven par un de ses admirateurs," *Essais d'Art libre*, vol. 2 (November 1893), p. 165.

Mauner 1963 Mauner, George. "The Nature of Nabis Symbolism," *Art Journal*, vol. 23, no. 2 (Winter 1963–64), pp. 96–103.

————————. "Gauguin or School of Pont-Aven—Concerning the Attribution of Two Panels in Stockholm," *Gazette des Beaux-Arts*, 6e Pd., vol. 74, no. 1210 (November 1969), pp. 305–10.

Mauner 1978 ————————. *The Nabis: Their History and Their Art*, 1888–1896, New York, 1978.

Natanson, Thadée. "IXe Exposition de la Société des Artistes Indépendants," *La Revue Blanche*, vol. 5, no. 18 (April 1893), p. 273.

————————. "Armand Seguin," *La Revue Blanche*, vol. 8, no. 41 (February 1895), p. 187.

Perruchot 1963 Perruchot, Henri. *Gauguin*, Cleveland and New York, 1963.

Perucchi-Petri, Ursula. *Die Nabis und Japan–Das Frühwerk von Bonnard, Vuillard und Denis*, Munich, 1976.

Rewald, John and Pissarro, Lucien. *Camille Pissarro, Letters to his Son Lucien*, New York, 1943.

Rewald 1962 Rewald, John. *Post-Impressionism, From Van Gogh to Gauguin*, New York, 1962.

Roger-Marx, Claude. *Bonnard Lithographe*, Monaco, 1952.

————————. *l'Oeuvre gravé de Vuillard*, Monaco, 1948.

Roskill, Mark. *Van Gogh, Gauguin and the Impressionist Circle*, Greenwich, Connecticut, 1970.

Russell, John. *Vuillard*, Greenwich, Connecticut, 1971.

Saunier, Charles. "Critique d'art—Salon des Indépendants," *La Plume*, vol. 5, no. 96 (April 15, 1893), pp. 171–73.

Salomon, Jacques. *Introduction à l'œuvre gravé de K. X. Roussel, Essai de catalogue*, Paris, 1967.

Joly-Segalen, Annie, ed. *Lettres de Gauguin à Daniel de Monfreid*, Paris, 1950.

Seguin 1903 Seguin, Armand. "Paul Gauguin," *l'Occident*, vol. 3, no. 16 (January–February 1903), pp. 158–67; ibid., no. 17 (March–April 1903), pp. 230–39; ibid., no. 18 (May–June 1903), pp. 298–305.

Minneapolis 1962 Selvig, Forrest. "The Nabis and Their Circle," *The Minneapolis Institute of the Arts Bulletin*, vol. 51 (December 1962), pp. 121–51.

Sérusier 1950 Sérusier, Paul. *ABC de la peinture*, Paris, 1950.

Spaanstra-Polak, Bettina H. *Symbolism*, Amsterdam, 1967.

Stein 1970 Stein, Donna M., and Karshan, Donald H. *l'Estampe originale—A Catalogue Raisonné*, New York, 1970.

Strachen 1969 Strachen, W. J. *The Artist and the Book in France*, London, 1969.

Sutter 1970 Sutter, Jean et al. *Les Néo-Impressionnistes*, Paris. 1970.

Sutton 1960 Sutton, Denys. "Roderic O'Conor," *The Studio*, vol. 160, no. 811 (November 1960), pp. 168–74, 194–96.

Sutton 1974 ————————. "Echoes from Pont-Aven," *Apollo*, vol. 79, no. 27 (May 1974), pp. 403–406.

Tuarze 1973 Tuarze, P. *Pont-Aven, arts et artistes*, Paris, 1973.

————————. *Pont-Aven, Paradis des arts*, Priziac, 1977.

82 **Vente O'Conor** *Vente O'Conor*, Hôtel Drouot, Paris, February 6–7, 1956.

Verkade 1923 Verkade, Dom Willibrord. *Le Tourment de Dieu*, Paris, 1923.

Vollard 1948 Vollard, Ambroise. *Souvenirs d'un marchand de tableaux*, Paris, 1948.

Walter, Elisabeth. " 'Le Seigneur Roy': Louis Roy (1862–1907)," *Bulletin des Amis du Musée de Rennes*, vol. 2 (1978), pp. 61–72.

Wildenstein Wildenstein, Georges and Cogniat, Raymond. *Gauguin, Catalogue*, Vol. I, Paris, 1964.

Exhibitions — Arranged by City and Date

Basel 1975 *Meisterwerke der Graphik von 1800 bis zur Gegenwart*, Basel, Kunstmuseum, November 1975–January 1976.

The Turn of the Century 1885–1910, Art Nouveau and Jugendstil, Cambridge, Mass., The Houghton Library, Harvard University, 1970. Catalogue prepared by Peter A. Wick.

Ker Xavier Roussel, Bremen, Kunsthalle, September–November 1965. Catalogue prepared by Günter Busch.

Bremen 1967 *Emile Bernard, Gemälde, Handzeichnungen, Aquarelle, Druckgraphik*, Bremen, Kunsthalle, 1967. Catalogue prepared by Henning Bock and Johann H. Müller.

Maurice Denis, Bremen, Kunsthalle, October–December, 1971. Catalogue prepared by Gerhard Gerkens, Jürgen Schultze, and Annemarie Winther.

Chicago 1959 *Gauguin: Paintings-Drawings-Prints-Sculpture*, Chicago, The Art Institute of Chicago, February–March 1959. Catalogue prepared by Samuel J. Wagstaff, Jr., Claus Virch, Harold Joachim, et al.

The Graphic Art of Vallotton and the Nabis, Chicago, Kovler Gallery, 1970. Catalogue prepared by Maxime Vallotton.

Three Swiss Painters: Cuno Amiet, Giovanni Giacometti, Augusto Giacometti, College Park, Pennsylvania, The Pennsylvania State University Museum of Art, September–October 1973. Catalogue prepared by George Mauner and Sandra Stelts.

The Outline and the Dot. Two Aspects of Post-Impressionism, Dallas, Museum of Fine Arts, March 1962. Catalogue prepared by B. Delabano.

Ritual and Reality: Prints of the Nabis, Lawrence, Kansas, Spencer Museum of Art, University of Kansas, March–April 1979. Catalogue prepared by Jeanne Stump.

Charles Filiger, London, The Reid Gallery, October–November 1963.

London 1966 *Gauguin and the Pont-Aven Group*, London, The Tate Gallery, January–February 1966. Catalogue prepared by Denys Sutton and Ronald Pickvance.

Roderic O'Conor—A Selection of his best Work, London, Roland, Browse and Delbanco, July 1971.

French Symbolist Painters: Moreau, Puvis de Chavannes, Redon and their Followers, London, Hayward Gallery, 1972.

Post-Impressionism, London, The Royal Academy of Arts, November 1979–March 1980. Catalogue prepared by Alan Bowness, Sandra Berresford, Frederick Gore, Anno Gruetzner, John House, Norman Rosenthal, and Mary Anne Stevens.

Mannheim 1964 *Die Nabis und ihre Freunde*, Mannheim, Kunsthalle, October 1963–January 1964. Catalogue prepared by Hans Fuchs.

Pont-Aven und Nabis, Munich, Gallerie del Levante, November–December, 1966.

l'Estampe en Bretagne, Nantes, Musée des Beaux-Arts, August–September 1974. Catalogue prepared by Claude Souviron.

The Color Revolution, New Brunswick, New Jersey, Rutgers University Art Gallery, September–October 1978. Catalogue prepared by Phillip Dennis Cate and Sinclair H. Hitchings.

New Haven 1965 *Neo-Impressionists and Nabis in the Collection of Arthur G. Altschul*, New Haven, Connecticut, Yale University Art Gallery, January–March 1965. Catalogue prepared by Robert L. Herbert, et al.

Painters at Pont-Aven, New York, Hirschl & Alder Galleries, October–November 1961.

Gauguin and the Decorative Style, New York, The Solomon R. Guggenheim Museum, June–September 1966. Catalogue prepared by Marilyn Hunt and Lawrence Alloway.

Charles Maurin 1856–1914, New York, Lucien Goldschmidt, Inc., November 1978. With an essay by Phillip Dennis Cate.

Le Groupe des XX et son temps, Otterlo, Rijksmuseum Kröller-Müller, April–June 1962. Catalogue prepared by F. C. Legrand.

Paris 1893 *Salon de la Société des Artistes Indépendants*, Paris, March–April 1893.

1re Exposition de H. G. Ibels, Paris, A la Bodinière Théâtre d'Application, November–December 1894.

Barc de Boutteville 1895 *Exposition Armand Seguin*, Paris, Galerie Le Barc de Boutteville, February–March 1895.

Gauguin, ses Amis, l'Ecole de Pont-Aven et l'Académie Julian, Paris, Galeries de la Gazette des Beaux-Arts, February–March 1934.

Cinquantenaire du Symbolisme, Paris, Bibliothèque Nationale, 1936. Catalogue prepared by A. Jaulme, H. Moncel, and E. Jaloux.

Gauguin et ses Amis, Paris, Galerie Kléber, 1949.

Eugène Carrière et le Symbolisme, Paris, Orangerie des Tuileries, December 1949—January 1950. Catalogue prepared by Michel Florisoone and Jean Leymarie.

Bonnard, Vuillard et les Nabis, Paris, Musée National d'Art Moderne, June–October 1955. Catalogue prepared by Jean Cassou, Bernard Dorival, and Agnes Humbert.

Dessins Symbolistes, Paris, Galerie Le Bateau–Lavoir, 1958. Preface by André Breton.

Les Sources du XXe Siècle, Paris, Musée National d'Art Moderne, November 1960—January 1961. Catalogue prepared by Jean Cassou, et al.

Filiger, Paris, Galerie Le Bateau-Lavoir, November–December 1962.

L'Ecole de Pont-Aven, Paris, Galerie La Cave, April–June 1978.

Pont-Aven 1961 *Gauguin et ses Amis*, Pont-Aven, Hôtel de Ville, August–September 1961. Catalogue prepared by Maurice Malingue.

Pont-Aven 1964 *Gauguin et ses Amis*, Pont-Aven, Hôtel de Ville, Musée de l'Association Paul Gauguin, July–September 1964.

Pont-Aven 1967 *Autour de Gauguin*, Pont-Aven, Hôtel de Ville, Musée de l'Association Paul Gauguin, July–September 1967.

Festival de Peinture, Pont-Aven, Hôtel de Ville, Musée de l'Association Paul Gauguin, June–September 1969.

Quimper 1950 *Gauguin et le Groupe de Pont-Aven*, Quimper, Musée des Beaux-Arts de Quimper, July–September 1950. Catalogue prepared by G. Martin-Méry.

84 **Quimper 1958** *Hommage à Sérusier et aux peintres du Groupe de Pont-Aven,* Quimper, Musée des Beaux-Arts de Quimper, July–September 1958. Catalogue prepared by Charles Chassé.

Quimper 1978 *L'Ecole de Pont-Aven dans les collections publiques et privées de Bretagne,* Quimper, Musée des Beaux-Arts de Quimper, July–October 1978. Catalogue prepared by F. Bergot, et al.

Le Bretagne, Saint-Denis, Musée Municipal d'Histoire et d'art, April–May 1961.

The Sacred and Profane in Symbolist Art, Toronto, The Art Gallery of Ontario, 1969. Catalogue prepared by Luigi Carluccio.

Retrospective: Henry Moret, Emile Jourdan, Roderic O'Conor, Wladyslav Slewinski, Vannes, Musée de Limur, 1966.

The Avant-Garde in Theatre and Art: French Playbills of the 1890s, Washington, D.C., Smithsonian Institution Traveling Exhibition Service, 1972. Catalogue prepared by Daryl R. Rubenstein.

Zurich 1966 *Pont-Aven: Gauguin und sein Kreis in der Bretagne,* Zurich, Kunsthaus, March–April 1966. Catalogue prepared by Denys Sutton, Ronald Pickvance, and Felix Andreas Baumann.